Lake Oswego
VIGNETTES

ILLITERATE COWS TO
COLLEGE-EDUCATED CABBAGE

Marylou Colver

THE
History
PRESS

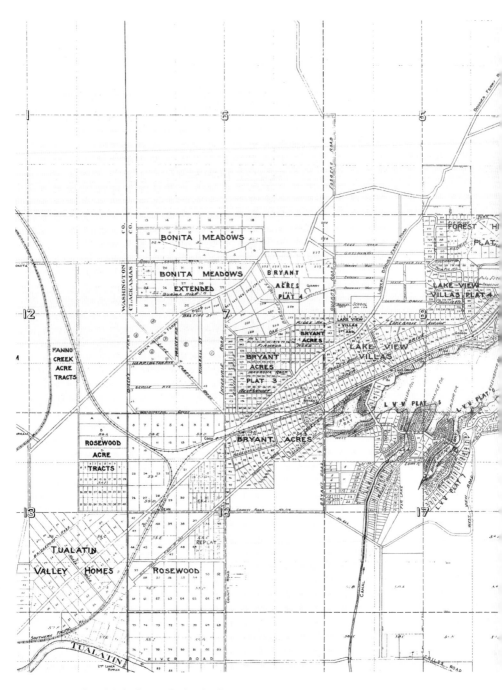

Courtesy of the City of Lake Oswego Engineering Department.

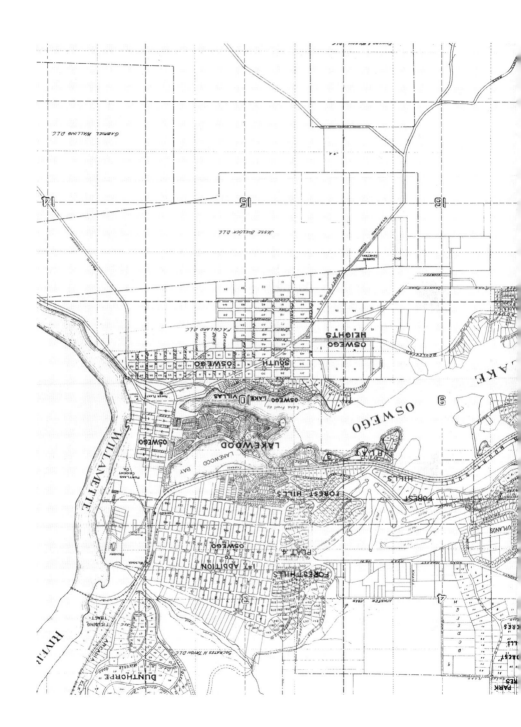

Published by The History Press
Charleston, SC 29403
www.historypress.net

Copyright © 2012 by Marylou Colver
All rights reserved

First published 2012

Manufactured in the United States

ISBN 978.1.60949.553.4

Colver, Marylou.
Lake Oswego vignettes : cows to college-education cabbages / Marylou Colver.
p. cm.
Includes bibliographical references and index.
SBN 978-1-60949-553-4
1. Lake Oswego (Or.)--History. 2. Lake Oswego (Or.)--Social life and customs. 3. Lake Oswego (Or.)--Social conditions. 4. Lake Oswego (Or.)--Biography. I. Title.
F884.L15C65 2012
979.5′41--dc23
2012002408

For Jack Walsdorf and the place that I love

CONTENTS

FOREWORD

T he rain fell lightly at the late summer dedication of Lake Oswego, Oregon's newest urban park, Sundeleaf Plaza (named after the architect Richard Sundeleaf), but no one seemed to notice. We found ourselves transfixed by the litany of Sundeleaf contributions to our city of distinguished homes and commercial buildings, some in sight of the Plaza. Marylou Colver held the microphone and eloquently conveyed, through her extensive research, the history of this man's imprint on Lake Oswego while highlighting familiar neighborhood landmarks. The ceremony was a fitting tribute to the architect and his family and another source of pride for those of us living in Lake Oswego.

Some thirty years earlier as bank president in Freeport, Illinois, I stood on broad boulevards lined with stately homes and conducted business in blocks of commercial buildings that predated the turn of the century. Midwest architects, such as C.W. Rapp and Frank Lloyd Wright, lent a direct influence to the structural designs of my hometown, a city that resembles the style, culture and significance of Lake Oswego. When I relocated to Oregon and founded The Bank of Oswego in 2004, I felt an immediate connection to the historical underpinnings of this community. Both Freeport and Lake Oswego were built on industry and enterprise. Freeport in 1827 on the banks of the Pecatonica River, and Lake Oswego along the Willamette River in 1850.

In meeting Ms. Colver, founder and president of the nonprofit Lake Oswego Preservation Society, we quickly formed a relationship based on mutual civic interest and respect. The Bank of Oswego's strong support of organizations that focus on education, the arts and the underprivileged earned us a sterling reputation as the "Community Bank." The Lake Oswego Preservation

FOREWORD

Society brings awareness of Lake Oswego's rich history by safeguarding the built environment, neighborhoods, landmarks and lore. I felt a compelling desire to honor and sustain the preservation society in these efforts.

In general, what you are about to uncover in this book is the importance of knowing our history. It's been said that "history is about increasing knowledge…but history also introduces us to ourselves. It connects us to our country, its achievements and failures, its heroes and villains, its ideals and aspirations." Ms. Colver clearly drives this notion home in both writings and deeds to the fortunate residents of Lake Oswego. What an auspicious gift!

More specifically, within the pages of this interesting book lie vignettes of our heritage through chapters ranging in subject from animals to transportation. This novel approach to storytelling will amaze, entertain and provoke thought and appreciation of the lives of our predecessors. Expect nothing less than flawless research and accuracy from this community's award-winning author as she demonstrates that, at times, "truth is stranger than fiction."

One vignette describes how the Nelson family established tent cottages in 1904 in a pine grove along the shores of Sucker Lake (now Oswego Lake). The four-foot, wooden-sided structures offered an amenity—an option to rent a four-person rowboat for the fee of one dollar—and became "the first commercial promotion of the lake for recreational purposes." I like to imagine the simplicity of that time as I survey the modern-day development of homes and boating activities on any given summer's day.

When asked if I would pen the foreword to Ms. Colver's book, an initial feeling of civic pride washed over me. The residents of Lake Oswego were warm in welcoming me to this community, and I am fortunate in knowing our bank's contributions help ensure our quality of life. In highlighting our collective history through the pages of this book, Ms. Colver and the Lake Oswego Preservation Society are making an indelible mark for now and generations to come.

And things tend to come full circle, given time and circumstance. It was a young lawyer from my home state of Illinois by the name of Abraham Lincoln who allegedly encouraged his client, Albert Alonzo Durham (a founder of Oswego, now known as Lake Oswego, Oregon), to head west. From the heartland to the Pacific Northwest, history forms a path on which we all travel. Enjoy the journey!

Dan Heine
President and CEO
The Bank of Oswego
Lake Oswego, Oregon
December 2011

ACKNOWLEDGEMENTS

M y heartfelt thanks to:

Erin O'Rourke-Meadors for her tremendous research skills and her passion for history and fact checking, which contributed significantly to the scope and accuracy of this book. Erin was also exceptionally supportive throughout this project.

Jack Walsdorf for his unfailing encouragement and insightful suggestions.

Susanna Campbell Kuo for sharing her extensive knowledge of Lake Oswego history and for proofreading the manuscript.

Bonnie Hirshberger, citizen information coordinator for the city of Lake Oswego, for accepting my offer to write about local history for the city's newsletter, *Hello LO*, in celebration of the 2010 centennial of incorporation. These stories became the basis for this book.

Dan Heine, president of The Bank of Oswego, for his support of the Lake Oswego Preservation Society and for contributing the foreword for this book.

Cliff Newell, reporter for the *Lake Oswego Review*, who has generously covered my local history endeavors, including the vignettes.

Bills Baars, library director, along with Carissa Barrett and Alicia Yokoyama, reference librarians, at the Lake Oswego Public Library. The oral histories published as *In Their Own Words*, the library's database of historic photographs, the original document archive, the local history vertical file and the index to the archives of the *Lake Oswego Review* were invaluable resources that provided both facts and inspiration. I'm grateful to the library staff for superbly fulfilling their mission of providing a collection of and access to local history resources.

ACKNOWLEDGMENTS

The staff of the Multnomah County Public Library for providing online access to the archives of the *Oregonian*, a major source of information for this book.

Aubrie Koenig, commissioning editor at The History Press, for guiding me through the publication process and for offering helpful suggestions along the way.

Gerald Morgan, who generously took the time to proofread the manuscript and to help with the creation of the index.

R.W. Helbock and Cath Clark, La Posta Publications, Harwood, Australia; Corinne Gill Steiger, Salem, Oregon; Martin Goebel, Salem, Oregon; Norm Gohlston, Portland, Oregon; Jeff Ward, Lake Oswego Corporation, Lake Oswego, Oregon; Bonnie and John Kroll, Lake Oswego, Oregon; Hilary Mackenzie, Mackenzie Architecture, Inc., Portland, Oregon; Kasey Brooks Holwerda, Lake Oswego, Oregon; and the Lake Oswego Preservation Society for kindly making images available for this book.

The Lake Oswego Preservation Society, a nonprofit organization, for its work in promoting the rich and often entertaining history of the city. Proceeds from the sale of this book will benefit the organization: www.lakeoswegopreservationsociety.org.

INTRODUCTION

In a 1956 issue of the *Paris Review*, William Faulkner wrote, "I discovered that my own little postage stamp of native soil was worth writing about and that I would never live long enough to exhaust it." Although Lake Oswego is not my birthplace, it has become "my own little postage stamp," and I will probably never exhaust its colorful and sometimes quirky history.

This book provides a lighthearted look at Lake Oswego's past. It is a mosaic of vignettes, not a linear chronology. In these pages you'll encounter thirsty cows that once roamed the town and drank from a public fountain while blatantly ignoring signs expressly forbidding it. You'll also find that acres of cauliflower, which Mark Twain dubbed "college-educated cabbage," were farmed in the Oswego area and trucked to Portland markets.

Even though each vignette stands alone, you'll discover recurring characters and themes. People you'll encounter range from Lola Baldwin, the first municipal policewoman in the United States, to the capitalists who founded Portland and shaped Oswego, such as William Sargent Ladd and Hermon Camp Leonard. One of the dominant themes is the town's transformation. The visionaries of the nineteenth and twentieth centuries saw Oswego's natural resources as a means to entirely different ends. For this reason, Oswego was reshaped from an industrial center to a residential-resort community, from the towns of Oswego and Lake Grove to the city of Lake Oswego and from Sucker Lake to Oswego Lake. In other words, it transitioned from pig iron to nine irons, from gritty to pretty.

Although the community was already 160 years old in 2010, the centennial of incorporation that year was a much-celebrated event. As part of the

celebration, I volunteered to write about local history for the city's newsletter, *Hello LO*. I had no preconceived notion regarding format or subject matter, but I was intrigued by the offbeat tidbits I discovered in my research, so I let those be my guide. With Erin O'Rourke-Meadors's help, we began in-depth research to make each piece as factually accurate as possible. Along the way, we ferreted out the odd facts that now introduce each chapter.

The previous histories of Lake Oswego, all penned by women, served as both an inspiration and a point of departure, given that I was taking a fresh approach in a unique format. By design, I wanted the vignettes to be brief enough to pick up and put down when convenient and to be crowned with a catchy or intriguing title. As I began to write, the format took shape, and I realized that my ultimate goal was to make history engaging for those not typically interested in the subject. The result is the book you hold in your hands. May these vignettes, these "postage stamps," send you to new and enjoyable destinations in Lake Oswego's past.

1

OUR TOWN
City History

DID YOU KNOW?

- Abraham Lincoln was the attorney for the Durham family when they lived in Springfield, Illinois. According to family lore, Lincoln urged Albert Alonzo Durham, who is often credited with founding Oswego, Oregon, in 1850, to head west.

- In 1966, a relief map of the Lake Oswego area was presented to the city. It took councilman John Maclean and his son Corky about six hundred hours to build, and it was indeed a relief when it was finished.

- Although the name Sucker Lake was officially changed to Oswego Lake in 1913, Sucker Creek wasn't renamed Oswego Creek until 1927. The name "sucker" had nothing to do with anyone on the shore; it was a fish that inhabited the lake, and one was not born every minute.

COMING TO OUR CENSUS

Oswego Village, which corresponds to today's Old Town neighborhood, first appeared as a separate listing in the United States census in 1880. At that time, the population totaled ninety-seven. The enumerators, the people who canvassed the residents, asked a series of questions and gathered such information as "Was the person idiotic?" This was a separate question from "Was the person insane?" Fortunately, making the fine distinction between these two mental states is no longer required of census takers.

If the person was sick on the day of the visit, the enumerator was to inquire about the nature of the sickness and note it for the record. Responses included typhoid fever.

By 1890, the question about ethnic identity expanded from the choices of "White, Black, Mulatto, Chinese, and American Indian" to include "Japanese, Quadroon, and Octoroon." After this one brief appearance, "Quadroon and Octoroon" disappeared from the U.S. census questions forever.

Percentagewise, the Oswego area was more ethnically diverse over a century ago than it is today. Thirty-three Chinese men were listed as living in the Oswego precinct in the 1880 census. Occupations for the townsfolk ranged from "Keeping House"—one listed for the majority of Caucasian women, as well as many Chinese men—to blacksmith, collier, miner, farmer, laborer and saloonkeeper. Eight-year-old John Bush was among several boys who listed their occupations as "At School."

Will the Real Oswego Please...

"A great city on a great lake." This is Oswego's motto—Oswego, New York, that is. There is a confusion of towns named Oswego from coast to coast. Oswego, New York, is located on the southeastern shore of Lake Ontario at

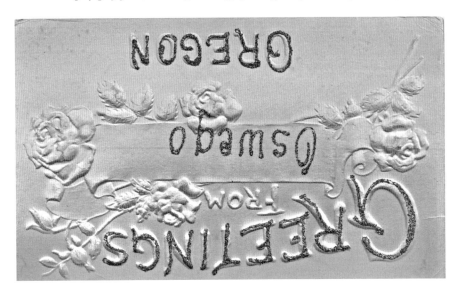

It's clear these greetings were from Oregon's Oswego. *Image courtesy of the Lake Oswego Preservation Society.*

the mouth of the Oswego River. There are some startling parallels between the East Coast Oswego and our town, which was simply named Oswego for 110 years. Oswego, New York, could also boast of a lake, a canal, a river, a historic country club, a vintage trolley and an ironworks. To muddy the waters, Hermon Camp Leonard, an early investor in Oswego's iron industry and for whom Leonard Street in the Old Town neighborhood was named, hailed from Owego (note the lack of an "s"), New York.

Rampant confusion continues westward with Oswego, Indiana; Oswego, Illinois; Oswego, Kansas; and Oswego, Montana, all built on or near a body of water. The name "Oswego" may derive from the Iroquoian Indian word "osh-we-geh," meaning "pouring-out place" or river mouth. This meaning is apt because Oswego, Indiana, with an estimated population of 175, is situated on the western shore of Lake Tippecanoe. The village of Oswego, Illinois, is located on the confluence of the Waubonsie Creek and the Fox River. Oswego, Kansas, sits on a bluff overlooking the Neosho River Valley, and Oswego, Montana, is on the Missouri River. The latter is the smallest Oswego, with a population, according to some sources, of just forty residents. The population dwindled from a high of seventy-five inhabitants after a prairie fire destroyed all but four homes in 1972.

A SQUARE PEG IN A ROUND TREE

The towering Douglas fir tree known as the "Peg Tree" still stands on Leonard Street in today's Old Town neighborhood. The name stems from the fact that early townsfolk hung a lantern from a wooden peg and held meetings under the tree's shelter. A lantern was used because Oswego was not electrified until 1908. The tree has been significant to the community since its founding in 1850. In addition to the Peg Tree, a few Douglas fir trees in the Old Town neighborhood also date back to the original grove.

Magnificent fir trees once lined Furnace Street in Old Town. Mary Goodall, in her book *Oregon's Iron Dream*, includes an interview with Elizabeth Evans Pettinger, who describes Oswego in the late 1800s: "The streets were roadways winding along among fir trees older than any person living now." Pettinger continues:

There was a great line of big heavy fir trees all along the river on Furnace Street. This tree-shaded band was a public playground for young and old in both summer and winter. The men from the two big boardinghouses

LAKE OSWEGO VIGNETTES

on Furnace Street liked to sit here and rest after their work on a summer evening and watch the river boats that plied up and down between Portland and Oregon City. One morning we saw the road supervisor come along and pretty soon all our beautiful trees were cut down.

FINDING A PLACE TO PARK

The Oswego plat, filed by John Corse Trullinger in 1867, set aside land between Leonard and Church Streets (in today's Old Town neighborhood) for a park. The park was never built, and the land was later developed. The community waited seventy-eight years for its first official public park, George Rogers Park, to be built. The area had served as a seasonal home for Native Americans, a shantytown for Oswego's Chinese laborers, a springtime gypsy camp, a steamboat landing and an unofficial park. Herbert Yates said, "The presence of the Chinese laborers need not surprise us as the Oregon Iron & Steel Company was booming in 1890 and the area of George Rogers Park, now occupied by the ball fields, was something of a small Chinatown." Yates also mentions that "the present site of George

Women enjoying a picnic in the park in 1930. *Photograph courtesy of Lake Oswego Public Library.*

Illiterate Cows to College-Educated Cabbage

Rogers Park made a perfect spring camping spot for gypsies who came somewhat regularly.

Herbert Letcher Nelson recalled, "What is called George Rogers Park now was always thought of as a park. It was a place where they had July Fourth celebrations and so on. It was level enough for a ball ground." In 1973, George Rogers's wife, Lottie, recalled that George "first became interested in parks about twenty years ago or so. He built the park up, which at that time was a pretty nice place; now it's kind of a weed patch. Well, he worked on the park from the time they started it until the time he died [1961], that was probably twenty years."

The Lake Oswego City Council named the park in Rogers's honor.

HONK IF YOU'RE ENLISTED

Amid gas rationing, the blackout ordinance and drives for paper, aluminum and tin cans, Theresa Truchot, an Oswego art and music teacher who later became a local historian, aided the war effort in her own unique way. In the 1940s, she published a newsletter for servicemen from the Oswego area humorously entitled *The Oswego Honk*. Truchot recalled, "When I sent this newsletter about Oswego, I thought that the most appropriate name for it would be *The Honk*. We were blessed with many ducks and mallards and little ones down on the Duck Pond [Lakewood Bay]."

The first issue is dated September 29, 1942, and it states that it will be "published when convenient." Instructions to the recipients include, "When you receive this, read it if possible, then mail it to the next victim on the list." Wartime postage for soldiers in combat zones was free, so Truchot relied on this to encourage round-robin circulation. Before the war ended in 1945, the subscriber list had reached one hundred.

A hand-drawn cartoon depicting a duck in flight served as the masthead. The newsletter was reproduced on an antiquated hectograph, a form of duplication that preceded photocopying machines. Hectographs were also known as "jellygraphs" because they used gelatin in the print process and are still used today to make temporary tattoos.

The homespun content was written entirely by Truchot. News tidbits included the opening of a new shoe shop, the progress of Oregon war bond sales, births, marriages and names of soldiers home on leave. These glimpses of hometown life hopefully transported local soldiers away from the realities of war for a brief "visit" back home. The subject matter and the hand-drawn cartoons, however, prompted one soldier to note, "Iowa isn't the only place one finds corn."

STREET SMARTS

The original streets of Oswego were officially named on January 10, 1867, when John Corse Trullinger filed the town plat. Albert Alonzo Durham reportedly had platted the town in 1850, but the plat was never filed. Trullinger used pig iron from the first Oswego casting to mark blocks one and two of the town site. The pig iron at Ladd and Durham is still in place. Many streets, as originally named, still exist. Kirkham Street, platted one block north of Leonard Street, is an exception and a mystery. What continues to stump local historians is the reason why a street was named "Kirkham."

It is probably a safe assumption that it was named after a prominent person like other streets in the original town site. Ladd Street was named for William S. Ladd, an Oregon Iron Company founder, one-time Portland mayor and the wealthiest man in the Northwest at the time of his death in 1893.

Durham Street, once named Durham Place, was named for Albert and Miranda Durham, who established the first Donation Land Claim for the town site in 1850. Leonard Street honors Hermon Camp Leonard, Oregon Iron Company vice-president. Corbett Street, which no longer exists, was named for Henry W. Corbett, a wealthy Portland capitalist and iron industry investor. Green Street honors the brothers Henry D. and John Green. The Greens, along with Ladd, signed the 1865 Oregon Iron Company's Articles of Incorporation.

Researchers have two theories about Wilbur Street. It may be named for Father Wilbur (James Harvey Wilbur), Oregon's early Methodist leader, or it may honor George D. Wilbur, a twenty-three-year-old Connecticut man who supervised construction of the furnace. The street that parallels Wilbur Street one block to the north is named Church Street because the first church in Oswego, the Methodist Episcopal Church, was nearby. J.C. Trullinger, A.A. Durham and C.W. Bryant incorporated the church on July 1, 1867. Furnace Street, on the bluff above the river, leads down to the iron furnace. General Ralph W. Kirkham of San Francisco served with Louis McLane, a director of Oswego's Oregon Iron Company, as a trustee of the Pacific Women's College, and they were both veterans of the Mexican War of 1846. There is a Kirkham Street in San Francisco named for the general. Perhaps he is also the namesake for Oswego's street. Until researchers can verify this assumption, the naming of Kirkham Street will remain a mystery.

Start the Presses

Jack DeVere Rittenhouse, an author and printer, observed:

> *Printing brings cohesion to society. The arrival of a printing press changes an outpost into a city. It democratizes learning by making it accessible to all. Each city, each region has dates that mark its birth and progress, and one of the most significant rites of passage is the arrival of the first printing press. From that point onward all is different, in part because the press has arrived.*

On October 12, 1891, the *Oregonian* reported, "H.L. Gill, late of the Olympia daily '*Tribune*,' a newspaper man of large experience, has recently taken up his residence at Oswego, and on the 17th will issue the first number of a weekly newspaper, to be called the '*Oswego Iron Worker*.'" Just four days before this announcement, on October 8, 1891, Herbert Lincoln Gill had purchased a second-hand nine-column Cincinnati Washington Hand Press, along with type, cases, a pair of column chases and other printing equipment,

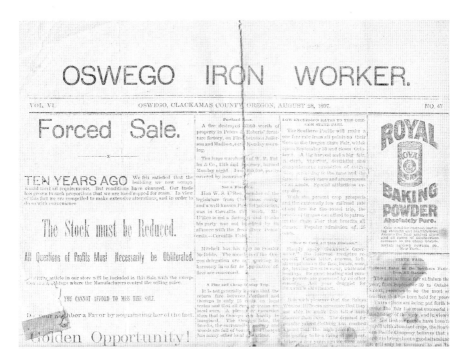

The *Oswego Iron Worker* masthead and some front-page news. This is the final issue, dated August 28, 1897. *Image courtesy of Corinne Gill Steiger.*

from Tatum & Bowen of Portland for $600 (about $15,000 in 2012 dollars) to be paid in four installments.

In addition to printing the newspaper, Gill served as an agent for the Phoenix Assurance Company; he was also a representative for Borthwick, Batty & Co. real estate, as well as an agent for the Oregon Iron & Steel Company's land in Oswego. An 1894 advertisement for the latter reads, "Buy now! Property in Oswego is as low as it will ever get." Gill was more prophetic than he could have ever realized.

Other advertisements in the *Oswego Iron Worker* included the Oswego Hotel, which touted, "Everything first-class. Choice wines, liquors and cigars. Pool room in connection." The Oregon Iron & Steel Company advertised "cast-iron pipe for water and gas in all weights and sizes. Special castings for water and gas works." The just-opened pharmacy in the Odd Fellows Hall advertised "drugs, medicines, stationery, confectionery, etc." and added, "A share of the public patronage solicited."

The iron operation shut down in 1894, but the *Oswego Iron Worker* continued to be published until August 28, 1897. Gill moved to Canby, and the building that housed the newspaper became the home of Fergus Lafayette Mintie, proprietor of Oswego Lumber.

IT'S OLD SCHOOL

There have been many school buildings in Oswego's history, including Hazelia, Trinity, the Grange Hall, Lake Grove, Springbrook and even a former saloon. None was as grand as the Oswego Public School, a two-story Victorian edifice erected in 1893. In addition to the principal, there were three teachers. With 274 "scholars," there could be over 60 students in a class. Arsenius DeBauw recollected in *In Their Own Words*, "I went to the school up here on the hill they tore down, where the Lakewood School is, right on that spot. And the Professor was Evans. And Mary Bickner was my teacher, too. She was a good one and so was Evans. He was a dandy professor. He had a small thumb on him and when he hit you with that thumb, you seen [*sic*; perhaps Arsenius flunked his English class] stars."

The Oswego Public School, the town's tallest building, survived for only thirty-five years. It was demolished to make way for a new school, later known as Lakewood School, which welcomed students on September 17, 1928. Luther Lee Dougan was the architect, and it cost $65,000 to

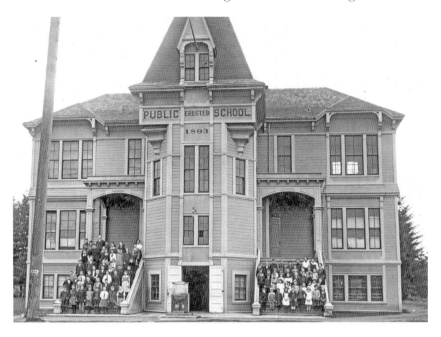

The Victorian-style Oswego Public School, built in 1893 and demolished in 1928. Photograph courtesy of Lake Oswego Public Library.

build. The school closed in 1980, and this Georgian-style building, after discussions about possibly using it as city hall, became the home of the Lakewood Center for the Arts.

"CAN DO" ATTITUDE

A British patent was issued for the tin can in 1810. This was an innovation in food preservation, but empty cans subsequently posed a problem. In 1936, a headline in the *Oswego Review* noted, "Old Tin Cans a Menace to Health." The article states, "The City of Oswego does not have a dumping ground and we have heard that the old furnace down by the river is being used for that purpose. We are also informed by the Ladd Estate Company that the above mentioned place should not be used in this manner. There is a garbage collector who will call at your door." Officers of the law were on the alert for those who tossed tin cans on Oswego's highways and byways.

The same year, on Twin Fir Road in Lake Grove, it was reported that Mr. Peterson invented a novel solution to the problem of disposing of tin cans:

he used them to build a root cellar. Root cellars were commonly constructed completely or partially underground so the lower temperature and steady humidity would help preserve root vegetables such as potatoes, carrots and turnips. Cellars were typically built of stone, wood or cement. Mr. Peterson's use of tin cans to build the entire structure was prompted by the high cost of brick and tile, plus he had spare time on his hands that summer. The newspaper article states, "The mere mention of a structure of any kind being built of tin cans is usually subject for a joke, but Mr. Peterson says the cellar is no joke with him and is rather proud of his accomplishment."

By the 1940s, tin cans were no joking matter. Tin was needed for armaments during World War II. Oswego, like other towns across America, held tin can drives. Hortense Slocum recalled:

> We had a mountain of tin cans, and what to do with them, we didn't know. So we sent out the word that we would have a potluck luncheon—everybody to come with their old clothes. And I want to tell you that there was a bunch of us, and a lot of women had never stamped a tin can flat in her life. Mary [Scarborough] Young, one of them, just hammered away at tin cans. And at the end of the day, we had enough mashed tin cans to fill a flat [rail] car.

THE INTERSECTION OF HEAVEN AND HELL

The Trinity School stood at the intersection of present-day Church and Furnace Streets, dubbed by some local pundits as the corner of "heaven and hell." Trinity was an Episcopal boarding school for boys that opened in 1856. In 1855, Reverend Thomas F. Scott, missionary bishop of the Protestant Episcopal Church of the United States in Oregon Territory, purchased sixty-seven acres from A.A. Durham for $400. An advertisement in the *Oregonian* from July 5, 1856, states, "The object will be the gradual and harmonious development of the child's spiritual, moral, mental, and physical nature, by exercises chiefly oral or conversational, calculated to unfold, train, and strengthen his various faculties." It was the first private school—and one of the first schools—in Oswego. The annual tuition of $200 was payable in advance, and it was noted that books, stationery and washing were not included.

At one time, the Reverend James R.W. Sellwood, one of the brothers after whom the Sellwood neighborhood is named, was an assistant teacher.

The two brothers had come to Oregon together by way of the Isthmus of Panama. Reverend John D. Sellwood was attacked in Panama; his nose was broken with a club, his hand was burned and he was shot in the chest, robbed and left for dead. Unbelievably, he survived this assault and made his way to Oregon to carry on missionary work.

The Trinity School closed permanently in 1866. The building was converted into a series of boardinghouses for workers at the iron furnace, and then it served as a private residence. After being abandoned, a fire destroyed it about 1900. The Trinity School was the forerunner of Portland's Bishop Scott Grammar and Divinity School, the Bishop Scott Academy and the Hill Military Academy. The school operated in Portland under the latter name until 1959.

OSWEGO GOES TO WAR

Almost seventy men from the Oswego area served in the War to End All Wars, or the Great War, which later became known as World War I. At home, citizens responded generously to fundraising appeals. In 1917, it was reported that a Red Cross drive "was a brilliant success for such a small town." The Oswego Woman's Club erected a service board on Front Street (now State Street) to honor those who served.

Two Oswego men, Corporal Loren Garfield Harrington and Private Thomas H. Elston, lost their lives. Harrington died on October 15, 1918, from wounds received in the Meuse-Argonne offensive. Elston died in France on June 24, 1918, of influenza. In 1921, when Oswego's World War I veterans decided to form an American Legion Post, they named it the Harrington-Elston Post in their memory.

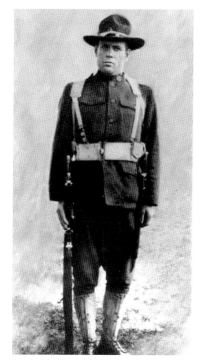

Loren Harrington in his World War I uniform. Harrington died in 1918 of wounds received in the Meuse-Argonne offensive. *Photograph courtesy of Lake Oswego Public Library.*

FROM PIG IRON TO NINE IRONS

In the span of a lifetime, Oswego transitioned from producing pig iron (raw bars of iron) to well-heeled golfers teeing off at the Oswego Lake Country Club. This remarkable transformation was the result of the work of many individuals, but one person was pivotal. Now mostly forgotten, Paul Cole Murphy had the vision to shape Oswego into a high-end residential district complete with world-class recreational amenities. From 1909 to 1921, Murphy devoted his Portland real estate career to developing Laurelhurst; he became involved in developing Oswego in 1923. The marketing firm

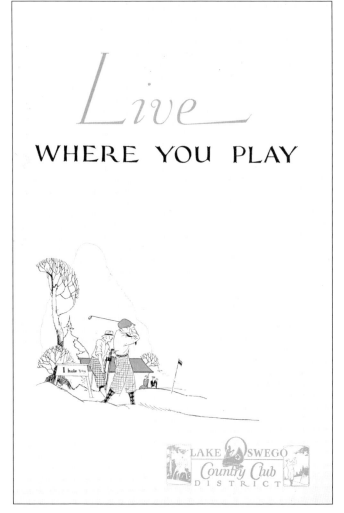

This 1926 brochure contains the first known use of the Ladd Estate Company's marketing slogan, "Live where you play." *Image courtesy of Special Collections and University Archives, University of Oregon.*

Atchinson & Allen had already spent a decade, beginning in 1912, marketing the Oregon Iron & Steel Company's land as real estate.

There are architectural renderings by both Roscoe Hemenway and Harold Doty for a Paul C. Murphy residence in Oswego, but Murphy continued to live in his Laurelhurst house on Burnside Street until his retirement to Santa Barbara in the 1940s.

Most likely Murphy is responsible for the well-used slogan "Live where you play." The first use of this marketing phrase dates to 1926. In 1927, the Ladd Estate Company sponsored the *Live Where You Play* radio hour on KGW from 6:00 to 7:00 p.m.

There isn't a street, park or civic building in Lake Oswego named after Paul C. Murphy, even though his vision shaped the town more than any other individual in the twentieth century.

GOOD ENOUGH FOR GOVERNMENT WORK

City Government

- In 1962, many townspeople were engaged in a battle to prevent a freeway from bisecting Lake Oswego. The proposed "Laurelhurst Freeway" was to connect the Baldock (now Interstate 5) and the Banfield (now Interstate 84) freeways. One proposed route was North Shore Boulevard and another was South Shore Boulevard.
- According to the *Oswego Review*, in 1938 Mayor William Ewing proposed a bicycle-licensing ordinance. This action was prompted, in part, by the careless array of bicycles left on the sidewalk in front of the library.
- In 1939, the city council awarded a contract for drilling a new well for the city water supply at Tenth and C Streets. Well done.

CITY HALL COMES UNDER FIRE

City officials often come under fire, so to speak, regarding controversial issues. On July 4, 1949, city hall literally came under fire when Barney's Home and Auto Supply store in the Oswego Lumber Company building adjacent to the 1926 city hall building on State Street went up in flames. Firemen from seven nearby towns helped fight the blaze. In the end, well over $100,000 of damage was done: one quarter block of the downtown business district was leveled, two city trucks were destroyed and three firemen were injured. It was reported that no city records were lost, but the

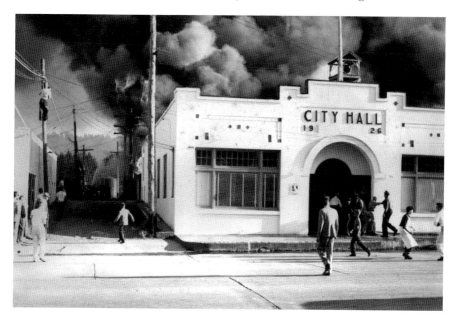

The fire behind city hall on the Fourth of July 1949. *Photograph courtesy of Lake Oswego Public Library.*

library that was housed in city hall at the time suffered heavy smoke and water damage.

Harold Jackson, the lumberyard owner, recalled that "youngsters throwing firecrackers into the lumberyard driveway for the added effect of an echo were chased away several times during the day." Cecelia Beckner said, "I do recall a fire on A Avenue. Jacksons had a large lumberyard, and there was also a hardware store there. About five thirty in the evening it was set on fire, I think by firecrackers. We were living on A Avenue at the time, and I have pictures of it. One of the fire trucks turned right over there on A Avenue that had come from somewhere else. It was a terrible fire with all the lumber going."

A Minor Inconvenience

A curfew bell was rung in medieval England as a signal for all to go to bed. Although it didn't involve a mandatory bedtime, on March 19, 1914, the Oswego City Council passed an ordinance prohibiting minors under sixteen years of age from being on the streets after certain hours. Minors were not

permitted to go abroad on the streets of Oswego after the hour of 8 o'clock at night during the months of October, November, December, January, February and March, or after the hour of nine o'clock at night during the remainder of the year unless such minor is accompanied by its parent or guardian, or have necessary business on the street.

BATHING SUITS BANNED

For over half a century, a concession operated from 1904 to 1957 on the southeast end of the lake. The Nelson family were the first proprietors, and they began by renting boats. As the lake grew in popularity, they added tent cottage rentals, an ice cream and candy stand and other amenities. About 1908, the Dyer family also operated a boating concession at the east end of the lake. By the 1920s, so many visitors on Sunday outings were strolling the town in bathing suits that city councilors banned the practice. Kenneth Davidson recalled that the Oswego marshal "gave tomatoes to boys, who threw them at people parading in swimsuits."

From 1924 to 1937, the concession was operated as McMillian's Resort and lastly as Morris' Lake Oswego Swim Resort. In 1957, city staff signed a $200,000 option to buy the property. City councilors opted not to pursue funding, and the Bay Roc apartment complex eventually supplanted the hopes for a public park on the lake.

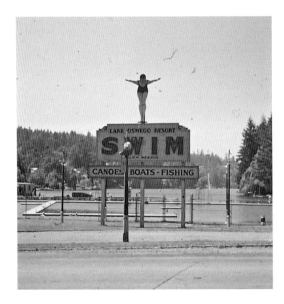

Allen Morris was the Lake Oswego Swim Resort proprietor. When this facility on the east end of the lake closed, public access to the lake ended. *Photograph courtesy of the Lake Oswego Preservation Society.*

Taking it to the Limit

Since 1910, several annexations have significantly changed the city limits. Twelve years after incorporation, the city of Oswego expanded beyond its original boundaries, which roughly corresponded to today's First Addition neighborhood. In a 1922 election, the annexation of Old Town and South Town (the latter is now mostly in the Hallinan Heights neighborhood) was approved by a vote of thirty-three in favor and twenty-one against. One defective ballot was also cast.

The iron industry, centered at the east end of the lake, had anchored the population. In 1912, the west end of the lake began to develop residentially. Growth was spurred by the arrival of the Red Electric trains; a new station named Lake View Park opened in 1913. By the following year, the station name had changed to Lake Grove, and this has served as the name for the area ever since.

The entire lake was not brought within the city boundaries of Oswego until 1959. Richard Harlow, a longtime Palisades neighborhood resident and a Lake Grove Sanitary District member, recalled that in 1955 the city "only surrounded the east end of the lake but the remaining area around the lake was unincorporated. This large area included the Palisades, Bryant Acres, Lake Haven Acres and part of Lake Grove." The three Sanitary District members realized that the rapidly growing area needed a sewer system, and this was the impetus for pursuing annexation. In 1960, two thousand residents and the entire lake frontage were officially brought within the city's boundary, hence "Lake" was added to the name "Oswego." The annexation of Mountain Park in 1969 eventually doubled Lake Oswego's tax base and population. A marketing slogan of the time was: "There's a new town in town." The city has grown from a population of 97 in 1880 to 36,619, according to the 2010 census.

How Much Is That Doggie?

In America, the practice of licensing dogs dates back to 1853, and it was a matter of concern for Oswego's first city government. In 1910, the city paid Portland's P.D. Cunningham Co. three dollars to manufacture one hundred metal dog tags. These tags were issued after the dog-licensing ordinance was passed by city council in 1911. All dogs over four months of age were required to be licensed. The cost was two dollars (almost fifty dollars in 2012)

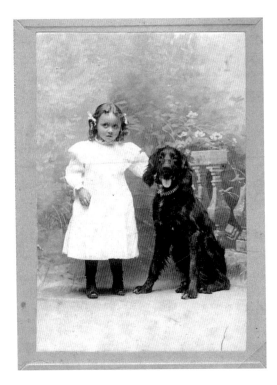

Emily Pomeroy photographed with her dog in 1896, fourteen years before dog licensing in Oswego. Emily was the daughter of James Henry Pomeroy, the superintendent of mines for the Oswego Iron Company, and his wife, Elizabeth. *Photograph courtesy of Lake Oswego Public Library.*

for every male dog and each spayed female dog and four dollars for every unspayed female dog. Imprisonment for no fewer than five or more than twenty-five days was one punishment for scofflaws.

GREAT BALLS OF FIRE

Balls, or at least dances, were held as an annual fundraiser for the Oswego Volunteer Fire Department in the 1950s. This revenue helped pay volunteers one dollar for every fire they fought.

From the city's beginnings, the possibility of fires was a concern. A conflagration in 1909 that destroyed two First Addition businesses was one of the worst fires in the town's history, and with it came renewed worries about adequate fire protection. In 1911, the year after the city of Oswego was incorporated, a volunteer bucket-and-ladder brigade was organized. Arthur "Red" McVey, for whom McVey Avenue is named, was one of the founders.

Fire protection technology took a leap forward when the bell from Portland's Couch School was purchased in 1915 to alert volunteers when a

fire broke out. This bell is currently mounted in front of the fire station on B Avenue. In *In Their Own Words*, William Banks reminisced:

> *I often wonder just what kind of fire we could have handled with just that one hose cart on a couple of wooden wheels and one nozzle. Apparently, everything was held under control pretty well. We had a good fire chief in those days. I believe his name was Bickner. Later on, when I came back to Oswego, in about 1924, and set up in business, we had a chemical wagon then made from a bootleggers' car that had been fixed up during the prohibition days.*

Oswego had another unusual piece of firefighting equipment. In 1937, a fireboat was launched on the waters of Oswego Lake, and the *Oregonian* reported, "Strange Craft on Lake Oswego [*sic*] New Fireboat."

VOTE EARLY AND OFTEN

In 1866, the *Oregonian* mentioned that Oswego had been platted and "the future city will soon be incorporated." Actually, by the time Oswego was incorporated in 1910, the town had been in existence for sixty years. Three previous attempts to incorporate had failed. The Oregon Iron & Steel Company, the largest landholder in the area, and the Southern Pacific Railroad had successfully opposed incorporation because they wished to avoid additional regulation and taxation. Residents of First Addition, the town's commercial center, had several reasons for advocating incorporation, including fire protection, water quality, debate over the sale of alcohol and promoting small businesses, as well as governmental autonomy. The vote in favor of the measure was seventy-nine to twenty-two. Only men cast their ballots because Oregon women did not win the right to vote until 1912; prior to that, they could only vote in school board elections.

POSTHASTE

The first post office in Oswego was established on December 31, 1853, making it one of the earliest in Oregon. At that time, Oswego was located in Washington County, but in November 1855, Oswego was changed to Clackamas County. Oswego's post office is one of seven in Clackamas

County formed before 1859, when Oregon was granted statehood. Wesley C. Hull was the first postmaster, and letters would be addressed with the recipient's name and the address "Oswego, O.T. [Oregon Territory]." The postmaster would advertise letters available for pickup in the *Oregon Spectator* newspaper.

In 1905, Jesse Coon, at the reins of his horse-drawn two-wheeled cart, delivered Oswego's mail. In 1910, Lester Clinefelter, known as the "whistling, singing boy on horseback," took over delivery. Clifford Johnson had the first delivery wagon in 1912, but the first day his team of horses saw it behind them, they kicked the ninety-dollar vehicle to pieces, and it had to be rebuilt. Johnson later had the first delivery by car, a Ford, but he had to chop the tree branches and brush out of the way to get through where horses had been able to go.

In 1937, the *Oswego Review* reported that "requirements for village delivery services are: a town population of at least 1,500 people within its boundaries [Oswego's population was 2,100 at the time], street names designated on street corners, and numbers of houses, sidewalks on both sides of the

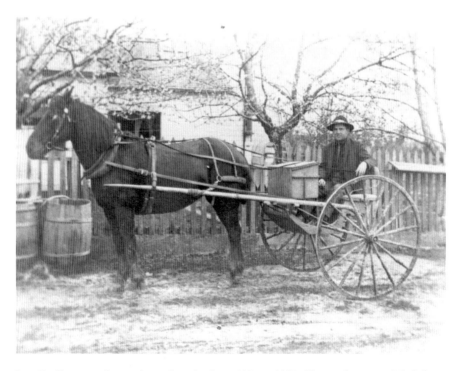

Jesse R. Coon was Oswego's rural carrier from 1905 to 1910. *Photograph courtesy of the Lake Oswego Preservation Society.*

street." A lack of sidewalks on one or both sides of the streets needed to be remedied to meet these requirements. Once this was accomplished, more mail deliveries could transition from rural routes to the more efficient village delivery. House-to-house mail delivery began in 1948. By 1953, all rural routes had been converted to city delivery.

JUMPING OFF THE BANDWAGON

The city of Oswego's charter, adopted on January 15, 1910, empowered city officials to enforce disparate regulations such as:

> *To regulate and prevent public criers, advertising notices, steam whistles, the ringing of bells, and the playing of bands.*
> *To prescribe the width of tires of all vehicles.*
> *To protect the public from injury by runaways by punishing persons who leave horses or carriages in the streets without being fastened.*
> *To regulate, restrain, and to provide for the exclusion from the city or any part thereof of stockyards, tanneries, slaughter houses, wash houses, and laundries, and all other offensive trades, occupations, and businesses.*

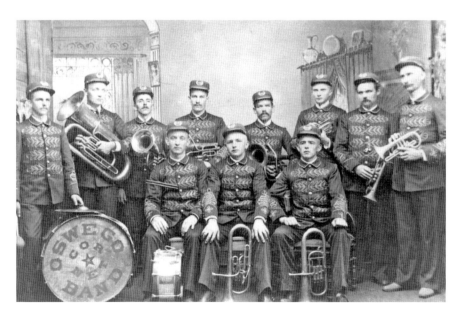

Fortunately, the Oswego Cornet Band played in 1893, prior to regulation by the first city officials. *Photograph courtesy of Lake Oswego Public Library.*

3

OF ALL PEOPLE

Townspeople

DID YOU KNOW?

- In the 1960s, the illustrator Richard Henderson Wiley used two Lakewood School students as models for Dick and Jane in the classic reader series.
- Eloise Jarvis McGraw of Lake Oswego, along with her daughter, Lauren Lynn McGraw, contributed several books to the Oz series started by L. Frank Baum. Their *Merry Go Round in Oz* was the fortieth and last official Oz book published by Reilly & Lee.
- In 1935, Oswego residents were in the grip of a chain letter craze.

GETTING HITCHED TO A STAR

Rock star, film idol, Nobel Prize winner, poet laureate, military brass, classical composer, Olympic champion, suffragette, world water-ski champion—Lake Oswego, to paraphrase Andy Warhol, has had its fifteen minutes of fame. Actress Julianne Phillips, who went to school in Lake Oswego, married rock star Bruce Springsteen on May 13, 1985, in Our Lady of the Lake Church on A Avenue. Humphrey Bogart and his Portland-born wife, Mayo Methot, reportedly honeymooned in a summer cottage on North Shore Drive, now known as Casablanca. Two-time Nobel Prize–winner Linus Pauling lived in Oswego briefly as an infant and spent many summers at his grandparents' house in the First Addition neighborhood.

Renowned local poet William Stafford was appointed United States Poet Laureate in 1970. From 1939 until their move to Agate Beach in 1941, Swiss-born composer Ernest Bloch and his wife lived near their son Ivan in Lake Grove. Nathan Farragut Twining, who became the chairman of the Joint Chiefs of Staff under President Eisenhower, grew up in a house that still stands in the Glenmorrie neighborhood. Swim coach Martha Schollander was a stunt swimmer in Johnny Weissmuller's Tarzan films. In 1964, her son, Don Schollander, was the first swimmer to win four gold medals in the Olympics. Sarah Evans, who once lived on Furnace Street, played a major role in the 1912 victory for women's suffrage in Oregon. Willa Worthington began water-skiing on Oswego Lake as a teenager and subsequently brought the town fame by garnering eight national and three international titles during her career on skis. Worthington was also a star performer at Florida's Cypress Gardens. So hitch your wagon to a star. After all, Clark Gable once worked as a tie salesman at Portland's Meier & Frank department store.

SCALAWAGS AND LITTLE DEMONS

The following article appeared in the *Oswego Review* on June 10, 1937:

> In almost every neighborhood where respectable people live there dwells a certain type of scalawag whose conduct makes him the subject of a lot of gossip, especially among the women.
>
> Morals don't mean a thing to him. He's unmarried and lives with a woman he's crazy about, and doesn't care what the neighbors say or think.
>
> He has no regard for truth or law. The duties of a good citizen are just so much bunk as far as he is concerned. He doesn't vote at either primaries or general election.
>
> He never thinks of paying a bill. He won't work a lick; he won't go to church; he can't play cards; or dance; or fool around with musical instruments or the radio. So far as known he has no intellectual interests at all. He neglects his appearance terribly.
>
> He's so indolent he'd let the house burn down before he'd turn in an alarm. The telephone can ring itself to pieces and he would not bother to answer it.
>
> Even on such a controversial subject as the liquor question, nobody knows exactly where he stands, because one minute he's dry and the next he's wet.

But we'll say this for him in spite of all his faults he comes from a darn good family and arrived June 1ˢᵗ—He's the new son and heir at the Dr. and Mrs. Christian Kisky home and will be known as Christian Norris Kisky.

Christian's younger sister, Karen, recalled that the "scalawag" grew to be a member of the "Big Demons" while she became one of the "Little Demons." The gangs joined forces to spy on their Greenbriar Road neighbor, Mr. Lindahl. Spying was warranted by Mr. Lindahl's highly suspicious act of feeding the ducks. At a meeting in their sylvan clubhouse, the Big and Little Demons determined that "their" ducks were being fattened for Mr. Lindahl's dinner table. There was no evidence to support this theory, but the demons were always looking for excuses to spy. In retaliation for this perceived wrongdoing, they broke Mr. Lindahl's milk bottles. This must have been a surefire way of conveying that the duck feeding must stop.

IT TAKES A TRIBE

Fraternal societies such as the Improved Order of Red Men, Odd Fellows, Freemasons and Woodmen of the World were common benevolent organizations during Oswego's early days. They particularly filled a role prior to public welfare programs, widespread insurance coverage and trade unions. Their good works included providing relief to members in sickness, covering funeral costs, giving aid to widows and helping to place orphaned children with families.

The Improved Order of Red Men, founded in 1834 and still in existence, is the oldest homegrown fraternal organization in the United States. The Kasseah Tribe Number 39 operated in Oswego. The Red Men Hall, built in 1925, still stands on the east side of Second Street between A and B Avenues. The Red Men were unique for adopting Native American regalia and rituals. For instance, their treasurer was called "keeper of wampum." These customs were meant to pay homage to the Sons of Liberty, who disguised themselves as Mohawk Indians during the Boston Tea Party of 1773. Prominent Oswego members included George Rogers, Carl Bethke, John Conway and Albert Rossiter.

The Independent Order of Odd Fellows dates back to seventeenth-century England. The term "odd" stems from the fact that the membership was derived from a variety of professions. An 1888 excursion on the steamboat *Joseph Kellogg* from Portland to Oswego helped raise money to pay for the building of the Odd Fellows Hall on Durham Place (now Street), and it was dedicated

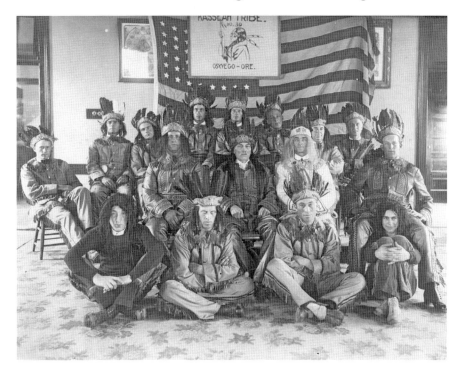

A meeting of Oswego's Kasseah Tribe Number 39 of the Improved Order of Red Men, a benevolent organization. *Photograph courtesy of Lake Oswego Public Library.*

in 1890. Many men linked with the town's early history, such as Henry Gans, Adam Shipley and George Prosser, were members. Townspeople came to the hall for dances, lectures and meetings and to cast their ballots on election day. The Odd Fellows are also known as the "Three Link Fraternity." Three intertwined rings, the organization's symbol, stand for friendship, love and truth. The hall still stands on the northeast corner of Durham and Church Streets in the Old Town neighborhood. The three links adorn the building that is listed on the National Register of Historic Places. In 1990, the exterior was restored and the interior was made into apartments.

GOING UNDERGROUND

Many upright citizens are now lying down on the job, and some have been doing so for over 100 years. Jerome Thomas, elected in 1910 as Oswego's first mayor, is buried in the Oswego Pioneer Cemetery. There are seven

other mayors to keep him company and to vie for leadership of the "silent majority" of 1,150 citizens buried in the cemetery. In the what-a-way-to-go category, causes of death range from falling lumber to electric shock.

As the name implies, the cemetery dates back to pioneer days. Originally, Jesse and Nancy Bullock set aside part of their Donation Land Claim as a family cemetery. In 1881, Jesse and his son-in-law, George Prosser, expanded the burial ground to include other families, and this became the Oswego Pioneer Cemetery on today's Stafford Road.

According to the *Oregonian*, when Adam Randolph Shipley, an Oswego pioneer and prominent member of the Grange, died in 1893, a procession of one hundred carriages accompanied his remains to the cemetery. When George W. Prosser passed away in 1917 at the age of seventy, 500 friends attended the service. This was quite a tribute considering that Oswego's population was about 1,500 at the time.

From 1892 to 1934, the Oregon Iron & Steel Company managed the Oswego Pioneer Cemetery, and many ironworkers are buried there. Portland's elite, the investors in Oswego's iron industry, needed an appropriate final resting place, so William S. Ladd founded Portland's River View Cemetery in 1882. Class distinctions may grow old, but they never die!

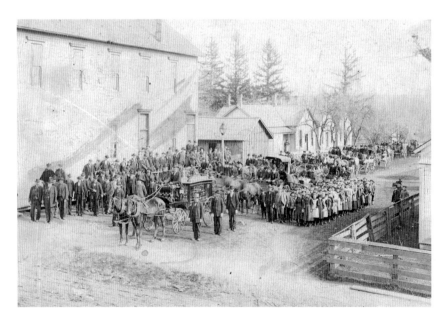

The February 8, 1895 funeral procession of Dena Prosser, the third wife of George Prosser, as it passes by the Odd Fellows Hall on the way to the cemetery. *Photograph courtesy of the Lake Oswego Preservation Society.*

They Didn't Stay to Iron It Out

Ohio's Hanging Rock region is named for a high sandstone bluff a few miles down the Ohio River from Ironton. The current population is 279, and it is now famous as a speed trap for unsuspecting motorists.

In the nineteenth century, it was in a major iron-manufacturing center, and this region supplied many workers for Oswego's early iron industry. The phrase "chain migration" is used to describe immigrants from a particular area who follow other family members or townspeople to a new location. Many workers settled in South Oswego, the area that is now the McVey/ South Shore Neighborhood, to work at the first furnace. Other workers at the second furnace, which went into operation in 1888, lived in New Town—in other words, First Addition. In 1891, Borthwick, Batty & Co. real estate agents targeted newcomers by advertising First Addition lots for $100 to $300.

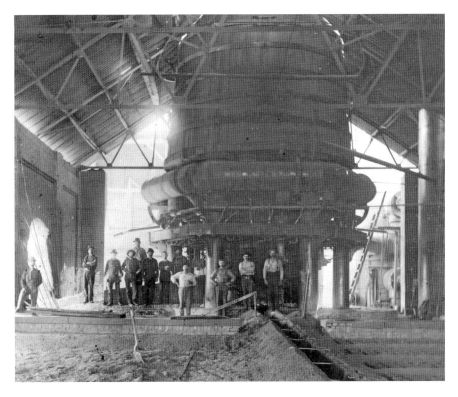

Many of Oswego's ironworkers, such as the ones pictured at Oswego's second iron furnace, and their families came from Ohio's Hanging Rock region. *Photograph courtesy of Lake Oswego Public Library.*

DOWN IN CHINATOWN

Oswego's Chinese population did much of the hard labor of building the early town and its industries. Herbert Yates recalled, "The presence of the Chinese laborers need not surprise us as the Oregon Iron & Steel Company in Oswego was booming in 1890 and the area of George Rogers Park, now occupied by the ball fields, was something of a small Chinatown." There are very few traces left of this segment of the population. They primarily performed manual labor, such as cutting fir trees to make charcoal to fuel the iron furnace, digging the canal from Sucker Lake to the Tualatin River by hand through solid rock and building the extensive landscaped grounds of Parker Farnsworth and Clara Morey's magnificent estate that later was subdivided to create Glenmorrie. They were also employed as cooks, and they ran laundries.

GYPSIES, CAMPS AND THIEVES

Itinerant gypsies lived up to their reputation for fortunetelling, dressing colorfully and being shrewd horse dealers. Ed Twining, who lived in Glenmorrie, recalled the annual gypsy camp at Oswego Landing, the beach on the Willamette River in what is now George Rogers Park. Twining remembered:

> Around Oswego there was one thing that always fascinated me, that sand bar at the mouth of Sucker Creek had a big gypsy camp every spring, most colorful thing you ever saw. They would bring their own horses and tents and plot around the country. They were pretty light-fingered, a very interesting bunch of people. I don't know why they quit coming. Maybe they won't let them camp there anymore. All I know is, they'd appear there on that sand bar, big camp of them. I'd estimate anywhere, depending on the time, seventy-five to two hundred and fifty of them, families and so on. Very colorful people. Those people with their families, tents and animals were just like flies on that sand bar, and they'd stick around for two or three weeks and permeate the country around here. You'd see them in the grocery stores and out on the farms. The last time I saw them was about during World War II time. I don't recall having seen them since.

QUITE A RECEPTION

Back in 1955, when television reception fluctuated with the level of the lake, Dr. and Mrs. Christian Kisky's home on Greenbriar Road was selected to be on a national television program, *The Home Show*. Dorothy Kisky didn't return the first call from NBC staff because she assumed it was a neighbor's practical joke. NBC staff called from New York a second time, and it clearly wasn't a prank. The Kiskys' wooden chalet–style house reflected their Danish heritage, and their house was selected in part because wood was the episode's theme.

The television crew spent two months, of which six weeks were on-site, preparing for the live show hosted by Arlene Francis and Hugh Downs. Dorothy recalled, "For six weeks you couldn't go to the bathroom and be sure that there wouldn't be some camera looking through the window or something. We had cables going in and out of the doors so that you couldn't lock up your house at night. And just no privacy, not nothing." Because of the East Coast time difference, preparations began at 3:00 a.m. on the day of the shoot to be ready for the 7:00 a.m. live broadcast. Pacific Telephone & Telegraph crews had strung one thousand feet of cable from the Kisky residence across the lake. Antennae installed on the top of Iron Mountain relayed the signal to Mount Scott and on to the company's central offices in Portland and then to a nationwide broadcast. The show featured young women in Jantzen swimsuits, the Kiskys' daughter Karen on water skis and a mother duck with her ducklings paddling on the lake in front of the house.

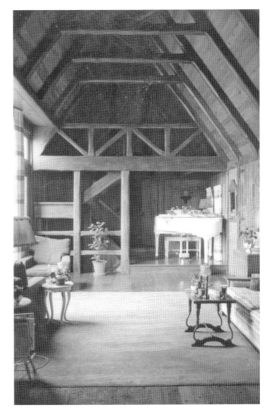

The interior of the Kiskys' home on Greenbriar Road. *Photograph courtesy of Lake Oswego Public Library.*

BETWEEN A ROCK AND A HARD PLACE

The near volcanic temperatures of the blast furnace had been dormant for decades, but the stone stack base that remained still provided shelter from the cold. At the height of the Great Depression that lasted from the stock market crash of 1929 until recovery began in the mid-1930s, fourteen men, homeless and unemployed, lived in the iron furnace in what is now George Rogers Park. According to a November 1931 *Oswego Review* article, Oregon state police officers and Oswego city officials forced the men from their encampment. The men had lived there for many months and had planned to stay in the shelter of the furnace through the winter.

SHABBY, NOT CHIC

Sara B. Wrenn interviewed several Oswego residents for the Federal Writer's Project in 1938 and 1939. In addition to their oral histories, Wrenn captured other details typically overlooked or omitted by interviewers.

J.R. Irving's place on Boones Ferry Road was described as follows:

> *Shabby living room of shabby old two-story house, built in the 70s. The room was high-ceilinged, heated by an airtight stove, the pipe of which entered a closed fireplace. The mantel, of white fluted lines, had once been beautiful. The room, as well as the rest of the house, was lighted by kerosene lamps; old-fashioned hanging lamps with flower-painted, thin China shades, hung from the ceiling by chains. At one end of the room was a bay-window, where a sewing machine stood. At the other end was a windowless recess, in which there was a sleeping cot and chair. Adjoining was a dining-room, the furniture of which bore evidence of more prosperous days. The garden about the house was apparently begun with much ambition for the future.*

This is the house that Mary Goodall tried unsuccessfully to save in 1970 as a fine example of the Carpenter Gothic style. Lastly, under the heading "Personal History of the Informant," Sara stated as a matter of fact that J.R. Irving had "no accomplishments."

Charles Delashmutt was "judged to be a man who has seen considerable of the seamy, adventurous side of life, with a capacity for enjoyment of whatever came his way. His house not particularly neat and no evidence of reading matter. Two dogs claimed a good deal of attention."

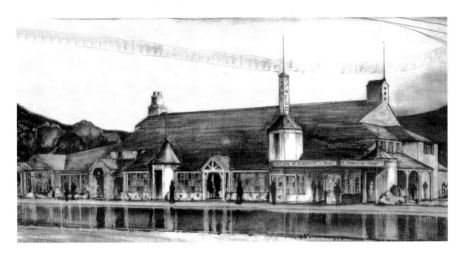

An architectural rendering of the theater complex designed by Richard Sundeleaf. *Satan Is a Blonde* is one of the films on the marquee. *Image courtesy of Hilary Mackenzie.*

1940 with *Another Thin Man* starring William Powell and Myrna Loy in the feature film. Admission was twenty-five cents.

The intent to build an English Cottage–style theater was initiated in 1930, and architect J.W. DeYoung's architectural rendering was published in the newspaper. DeYoung also designed Portland's Paramount Theatre, and he did the complete set of working drawings for the Hollywood Theatre, although the latter was not built from these in the end. The final Sundeleaf design is very similar to DeYoung's conceptual drawing. The Great Depression may have interfered with the original plans.

During World War II, the Lake Theatre screenings included many war films, such as *Yank on the Burma Road* and *The Wife Takes a Flyer*. After the war, Joan Fewless Quigley recalled, "The Lake Theater in Oswego beckoned with Esther Williams movies and other 1945 assorted attractions and many of us young people would go to the movies on Sunday afternoons." Three businesses opened in conjunction with the theater: Ireland's on the Lake restaurant, Clever Cleaners and the Theatre Ice Cream Store.

SKIRTING THE ISSUE

Hops, used for making beer, yeast and medicine, were introduced to Oregon in 1867. Between World Wars I and II, Oregon was one of the world's largest hops producers. Locals had seasonal work in stringing hop vines to wires,

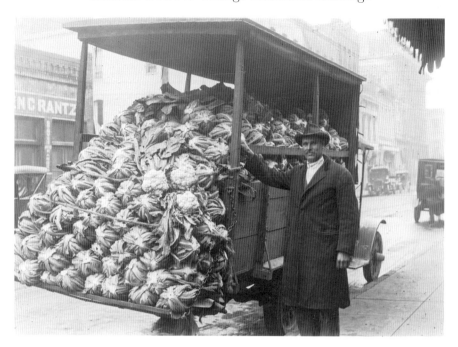

Charles W. Kruse taking cauliflower, also known as "college-educated cabbage," to market. *Photograph courtesy of Lake Oswego Public Library.*

Kruse won the Certificate of Merit award from the Oregon Agricultural College in the Corvallis Hort[icultural] Show in 1922.

Harold Kruse remembered, "In the summertime we'd plant cabbage and stuff. We raised a thousand tons of cabbage there for the pickle works. We would haul it to town [Portland] with horses." Kruse transported his crop to Portland, first by horse-drawn cart and later by truck.

In 1926, the Kruse cabbage farm made the news. An airplane flown by two Portland air service reserve officers ran out of gasoline and crash-landed in C.W. Kruse's cabbage patch, where Westlake is now located. The airplane was a complete wreck, but Lieutenant J.T. Kern and Sergeant George Drew escaped with minor injuries.

SATAN IS A BLONDE

One of Richard Sundeleaf's architectural renderings for the Lake Theatre shows two films on the marquee: *Satan Is a Blonde* and *March of Time*. It appears that these film titles were fictitious. The theater actually opened in

4

GETTING DOWN TO BUSINESS
Agriculture and Business

DID YOU KNOW?

- The Hazelia area was once called "The Island." When the canal was built from the Tualatin River to Sucker Lake in 1871, this area, also bordered by the Willamette River and Sucker Creek, was surrounded on all sides by bodies of water.
- Murphy's Auto Camp was located on the west side of Pacific Highway (State Street) in Oswego in the 1920s. The rate for camping was $0.50 a night, and cottage rentals ranged from $1.00 to $2.00 per night.
- G.W. Walling of Oswego created "Major Francis," a cherry seedling, circa 1865. A committee named it in honor of Major Francis of Portland. The fruit was reported to be "large, dark, fine flavor, early, and too tender for long shipment."

COLLEGE-EDUCATED CABBAGE

Mark Twain said, "Cauliflower is nothing but cabbage with a college education." Both cauliflower and its less-educated cousin, cabbage, once played a large role in Oswego's agriculture. Pearl Kruse recalled, "The *Oregonian*, on November 9, 1913, had an article about the cauliflower they [Kruse family] were raising. It was under the heading 'New Industry Is Thriving in the State.' It showed pictures of Charles [Kruse] and the fields of cauliflower." Cauliflowers and cabbages were entered into fairs, and Charles

A.J. Howell's house at Second and C Streets was described as

> *comfortably, but plainly furnished living-room of two-story house, built some 20 or more years ago, and standing on a corner lot of the village of Oswego; in a section where the streets remain ungraded, unpaved and without sidewalks. Oswego is one of the oldest villages in Oregon, and bears much of* [folklore atmosphere?] *with its numerous little old-fashioned houses, its shade-trees and its unimproved streets more like grassy lanes.*

hoeing weeds and, later, harvesting hops when they ripened in August and September. Women and teenagers were the fastest pickers. Hops were placed in a basket, and two baskets filled a sack. Local families gathered together, and picking hops was a source of income as well as a seasonal social event. Harvest time was an occasion for dances and other entertainments. Hop picking was not without controversy. In 1906, a debate raged in the Oregon press over whether women picking hops should be allowed to wear pants. From turn-of-the-century photographs, it appears that Oswego women did not follow suit, so to speak, and they picked hops wearing dresses.

It's difficult to fathom from a modern perspective, but whether or not women should wear pants, an exclusively masculine garment, was a highly controversial issue at the time. Later in history, women occasionally wore pants for wartime and industrial jobs, but it wasn't until 1970 that women's pants became fashionable and truly accepted. U.S. legislation passed in 1972 signaled the end of dress codes, and women could no longer be required to wear dresses. At the time, C. Herald Campbell, who later became mayor of Lake Oswego, was personnel director at Pacific Power & Light Company. Campbell celebrated the change in the company's dress code by wearing his kilt to work on the day female employees first wore pantsuits.

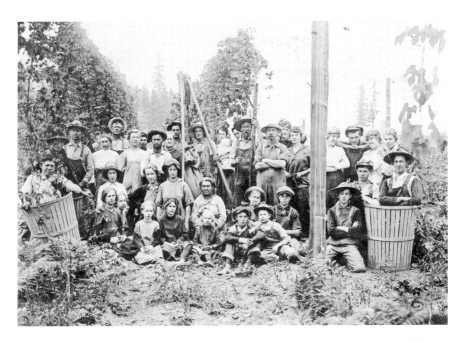

Oswego hop pickers at harvest time. Notice the two men on either side who "hopped" into the baskets. *Photograph courtesy of Lake Oswego Public Library.*

IT RINGS A BELL

The Herbert Letcher Nelson family installed the first telephone in town in 1910 to take reservations for their increasingly popular boating concession. The family ran the Nelson's Boat House on the east end of the lake. For outgoing calls, they charged a nickel. In 1918, the Home Telephone Company serviced the Oswego area and installed a new switchboard that prevented operators from listening in on conversations. The capability for "harmonic ringing" was also added. The latter was a system for party lines—in other words, a single line shared by multiple households—which rang only the bell of the desired party. Oswego's first telephone connection with another continent was a crystal-clear, two-minute conversation with a party in Buenos Aires, Argentina, in October 1930. Mrs. Lula A. Baker, chief operator at the Oswego office of the Pacific Telephone and Telegraph Company, placed the call. The charge was forty-eight dollars. By 1931, Oswego had a total of 511 telephones.

COW COUNTRY CLUB

Prize Jersey livestock with names such as Merry Miss Oonette, Darling Glow Crews and Sultan's Birdie once grazed on William Mead Ladd's Iron Mine Farm in Oswego. William Mead Ladd, William Sargent Ladd's son, formed

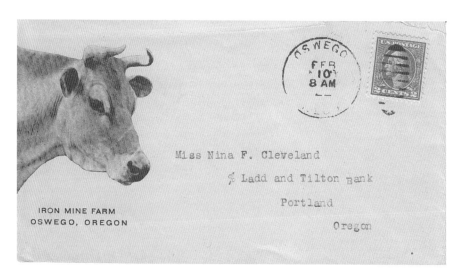

An Iron Mine Farm envelope featuring an unidentified cow. Perhaps it's Merry Miss Oonette? *Image courtesy of the Lake Oswego Preservation Society.*

the Ladd Estate Company in 1908. The Ladd Estate Company converted several family-owned Portland-area farms into residential developments. When the Crystal Springs Farm became Eastmoreland, Westmoreland and part of Reed College, the livestock were relocated to Iron Mine Farm.

Country club districts near large cities were a trend sweeping the nation in the 1920s, and by 1925 Iron Mine Farm had been converted, at a cost of half a million dollars, into the Oswego Lake Country Club. The country club was central to the Ladd Estate Company's recreational-residential vision for Oswego. In the surrounding districts, street names such as Prestwick, Westward Ho, Troon and Glen Eagles honored famous United Kingdom golf courses. Former Seattle mayor George F. Cotterill served as the engineer on the project, architect Morris H. Whitehouse designed the Arts and Crafts–style clubhouse in 1925 and Henry Chandler Egan laid out the eighteen-hole course. Egan later remodeled the course at Pebble Beach, and he designed many other courses in addition to being an accomplished amateur golfer.

THE APPLE FELL FAR FROM THE TREE

In 1917, Mrs. Edgar Davidson, wife of the then Oswego postmaster, displayed an apple for all to see in the post office window. The reason this apple, sent by parcel post from Connecticut, was special is that it was sent by Mr. James B. Wilbur with the following note:

> In 1866, my brother George D. Wilbur, went to Oswego, Oregon and built a Blast Furnace, leaving Sharon, Conn. about April 1st. At that time there was no railroad across the continent, and he sailed from New York to the isthmus of Panama crossing that and again sailed from there for Portland, Oregon and again from there to Oswego, where he remained at work as foreman, about ten months.

Wilbur was only twenty-three years old when he supervised construction of the furnace. The note goes on to say that Wilbur took apple and pear grafts with him when he returned to Connecticut. They were wrapped in oil silk—silk treated with oil to make it watertight. The Oregon apple proudly displayed was grown in Connecticut from the graft.

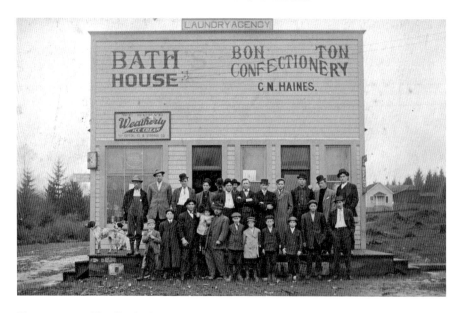

The store owned by Charles N. Haines is pictured about 1910. Haines, without a hat, is in the center of the photograph. The dogs, also without hats, are named Sport and Heenie. *Photograph courtesy of the Lake Oswego Preservation Society.*

CIGAR WITH THAT ICE CREAM?

Early merchants offered what may now strike us as a curious combination of goods. Edgar L. Davidson was the proprietor of a drugstore. A 1914 bill of sale for this business touted drugs, as well as cigars, ice cream and Notox, a poison oak remedy. It also listed Davidson's roles as city recorder, justice of the peace and public notary. Davidson later added postmaster to his accomplishments. E.L. Davidson was the son of pioneer Lucien Davidson, a carpenter who helped build many of Oswego's early buildings.

Another local merchant, Charles N. Haines, had a business on the northwest corner of A and First Streets. Among other offerings, the store combined a utilitarian bathhouse, the lofty-sounding Bon Ton Confectionery and a laundry agency. After Oswego's incorporation in 1910, Haines served as the town's first marshal.

COWGIRL OF THE GOLDEN WEST

The Oswego Commercial Club, a Lake Oswego Chamber of Commerce precursor, was founded in 1912 to "promote industries in the locality of Oswego." In 1937, one of the club's marketing ideas, based on Portland's lead, was to have a "hospitality girl" to represent Oswego. Perhaps the "western hospitality" concept was taken too literally. According to the *Oregonian*, "These lovely maids should be glorified in a Ziegfeldian manner in costumes that exemplify the golden west." The club adopted a resolution to "select an Oswego girl, dress her in fetching western costume and present her to Mayor Carson [of Portland] as one of his pulchritudinous hostesses." The following month, November 1937, a blond beauty named Marie Nemec was chosen as Oswego's "hospitality girl." Decked out in a cowgirl outfit, she was to represent Oswego at state and county fairs, as well as the 1939 Golden Gate International Exposition in San Francisco.

HOME ON THE GRANGE

The National Grange of the Order of Patrons of Husbandry is the full name of the organization most often referred to as the Grange. It began in 1867 as an organization for farmers to share ideas and cooperate in other ways. Seven years later, in 1874, the Oswego Grange Number 175 was established. Unlike other organizations that were strictly fraternal, women and children were welcomed and encouraged to join the Grange, and women also served as officers.

Maude Grimm, in *In Their Own Words*, recalled that her great-grandfather Adam Randolph Shipley helped organize the Grange, and he

> shared his property with his organization. The first Grange Hall was built halfway up the butte, a large hill on his land. On the top was the burying ground of the Willamette Indians, which he would not let anyone molest. A small trail was the only way to reach the building. The Grange occupied this building until 1890. Mr. Shipley was the first Master. He was also the third State Master.

Access was by a team of horses or on foot. At least one member reportedly carried his shoes to save the wear and tear on them. Unfortunately, a fire destroyed this building, along with all of the Grange records, so the Grange

A wedding held at the second Oswego Grange Hall in 1896. *Photograph courtesy of Lake Oswego Public Library.*

moved into town. In 1890, pioneer Lucien Davidson helped build Oswego's second Grange Hall, which stood on the northwest corner of Furnace and Leonard Streets in today's Old Town neighborhood.

The Grange also served as a social hub for the community. Iva Montgomery remembered, "The Grange was very active. They gave dances, fairs, had auction sales of homemade quilts and farm produce and had very good dinners." At meetings, both men and women gave lectures; at fairs, awards for horticultural entries, as well as for handiwork such as fancy pincushions, were presented; and the Grange Hall served as a wedding venue as well as a schoolhouse.

When the third Hazelia School closed in 1948, the property ownership reverted to the Shipley family. Agnes Shipley Lehman, the only living heir, donated the 1916 schoolhouse building to the Oswego Grange, and the hall in Old Town was sold. There were very few Grange members remaining when a fire destroyed the schoolhouse building in 1974, exactly a century after Oswego Grange Number 175 was founded.

Shop Talk

The following article, entitled "Something Oswego People Should Give Serious Thought," was published in the *Oswego Review*:

> *Do you know: That you can buy practically anything you need in Oswego? That the money you spend with your Oswego merchants contributes towards the welfare and development of the Oswego-by-the-Lake community in taxes, in payroll, in real estate and many other ways.*
>
> *Do you know: That the money that you spend with these merchants may be the means of providing employment for another Oswego man? That in so doing, your grocer, your butcher, your lumberman, your printer, your electrician, your plumber, your druggist and even your postmaster are able to give you better service?*
>
> *Help your merchants to grow and prosper, they are the keystone of your community. When they prosper you prosper and when you prosper your community prospers and we are all able to partake of the better things of life including civic development.*
>
> *Spend your money in Oswego and watch it grow.*

was reported, "They have two looms going, weaving their own patterns and cloth from which they make ties, bags, etc." The building on Lakewood Bay that once housed the transformers for the Red Electric trains was used in the 1940s as the production facility for the Oswego Weavers.

The company produced nationally famous "Oswego Hand Made Ties." Men originally operated the handlooms that were capable of weaving from one yard to forty inches in width. As World War II escalated and men enlisted, women worked the looms. Theresa Truchot remembered:

> *The old power plant on the railroad track was made into a necktie factory. Mr. Cook helped me to get a job there working in the factory. I just loved it because you did certain things. You had cloth in front of you to make neckties and you cut them at a certain angle and it was very particular. Then they sold out or closed down and so I didn't have a job.*

Actually, the company was forced to shut down for the duration of the war because of a labor shortage. The building was then enlarged and converted into the Lake Front apartments to help address the housing shortage during the war. After the war, the Oswego Weavers went back into production in a facility in Oak Grove and were later absorbed by the Oregon Worsted Mills. The building has undergone several transformations and is currently a condominium complex.

The label of a tie hand loomed by the Oswego Weavers. *Image courtesy of the Lake Oswego Preservation Society.*

their mother with the jams and jellies, and I was a little boy and sold berries to them, they worked in a sort of small shed out beyond the kitchen. I think they had a big stove there and a big stove in the kitchen and they worked on the back porch. It was a very simple, primitive sort of plan by which they put these jams and jellies together. And it was just the very beginning of this industry.

A 1932 obituary for Florence Dickinson notes:

In addition to her 40 years' work in the Grange at Oswego, she was an expert on grape culture and founded and managed the Dickinson Products company, manufacturers of jellies, jams and grape juice. Mrs. Dickinson was the first woman to talk over the Bell telephone system in Portland.

One newspaper account credits her with proving, against popular belief, that Concord grapes could be successfully grown in Oregon.

In a 1938 Works Progress Administration interview with Florence's husband, Charles Towt Dickinson, he noted:

They began by taking orders for jams and jellies from people in Portland. They would take the orders early in the fruit season and in autumn deliver to the various families. The first year, he said, they put up about six-dozen containers. The second year there were five barrels of 25 doz. containers each. The third year he ordered his glasses by the carload. From that time on they had a well-established business that is thriving today [1938].

Another distinction came with the opening of Disneyland on July 18, 1955. The Dickinson Company was picked to operate a jam and jelly concession on Main Street. A 1960 television program about the Dickinsons gives credit for the quality and flavor of one of their jams to the *Rubus vitifolius*, or wild mountain blackberry. The J.M. Smucker Company acquired the business in 1979 and continues to sell preserves under the Dickinson label.

TIED UP IN KNOTS

In 1935, Mr. Roy Glenn Trierweiler and his wife, Mary Elizabeth, relocated to Oswego from Santa Fe, New Mexico, and started a business. It was initially called the Indian Tie Company and was later known as Oswego Weavers. It

5

INDUSTRIAL STRENGTH
Oswego's Industries

DID YOU KNOW?

- What did Oswego have in common with Mayville, Wisconsin? Both towns shared the dream of becoming the "Pittsburgh of the West." Other contenders included Llano, Texas; Pueblo, Colorado; St. Louis, Missouri; Butte, Montana; Terre Haute, Indiana; Everett, Hamilton and Kirkland, Washington; Richmond, California; and Eureka, Nevada.
- One of Oswego's two iron mines, the Patton mine, was a strip mine.
- Jeannie Foster Kennedy, wife of Robert Pim Butchart, one-time president of the Oregon Portland Cement Company at Oswego, created Butchart Gardens from a former limestone quarry near Victoria, British Columbia.

OSWEGO IN A JAM

In 1897, Florence Smith Dickinson started making jams in her Oswego farmhouse kitchen, and this homespun enterprise grew into a world-renowned industry. The business began in the Dickinson home on Stephenson Road. Arthur Jones said:

> *I remember seeing on a store shelf in London, Dickinson Brothers Jams and Famous Jellies* [sic]*, which are sold all over Western Europe and South America, as well as America. When the Dickinson brothers were helping*

This article appeared on November 2, 1938. Although there is a current emphasis on "buy local" campaigns, we have realized for at least seventy-five years that if we don't shop locally we won't have local shops.

That's Mr. Burger to You

The Gables restaurant was located in Lake Grove on, as the menu stated, the "corner of Lake View Boulevard and South Shore Drive (just around the curve from the Lake Grove Swimming Park)." Gibson C. Kingsbury was the manager, and the slogan was: "Where fine foods and friends meet."

The Gables is remembered as an upscale restaurant whose specialty was hamburgers. For fifty cents, the Mr. Burger Sr. came with French-fried potatoes and a small salad. It was, the menu noted, "A Meal." For less hearty appetites or budgets, the Mr. Burger Jr. came with potato chips and a pickle for thirty cents. One could top off a meal with the thirty-five-cent mystery dessert, the "Gables Surprize [*sic*]." It is now a private residence, but the Gables sign still hangs on the building. At one time, a sign painted on a large rock on Iron Mountain Boulevard pointed the way to the restaurant.

BOOMTOWN

Oswego was once a short-lived boomtown. In September 1922, the *Oregonian* reported the incorporation of the Oswego Log & Boom Company, which was sponsored by large timber and lumbering interests. The company petitioned the state public service commission to use Oswego Lake for log storage. It was proposed that the logs would be transported by train and dumped into the lake. This scheme, it was reported, "has greatly aroused property owners along the lake who see in the proposed commercial use of the beauty spot a trampling of their rights and a minimizing of their property values, in addition to an impediment to boating." Understandably, the Oregon Iron & Steel Company, the owner of the riparian rights along Oswego Lake, was also opposed to the plan, and it suspended sales of lakefront lots until the outcome of the petition could be determined.

The other part of the Oswego Log & Boom Company's plan was to build a chute, a flume or a skid road between the east end of Oswego Lake and the Willamette River to get the logs to ships when the mills were ready to take delivery. After much hue and cry, the petition was denied, and by June 1923, the Oswego Log & Boom Company filed for dissolution.

A PIPE DREAM

Prior to the manufacture of metal pipe, water was piped through hollowed-out logs. In 1888, the Oregon Iron & Steel Company built a second iron furnace in what is today's Foothills area. Five hundred yards north of the furnace, it constructed the Oswego Pipe Foundry, the first pipe foundry west of St. Louis. The foundry was awarded the contract for manufacturing the cast-iron pipe for Portland's Bull Run water system. Twenty-five tons of cast-iron pipe a day were manufactured. Herman Blanken recalled:

> *They made the pipe here, forty-five-inch cast-iron pipes. They had a big furnace where they melted it, and a monster big crane in there. And this crane had like a dipper on it. They would put in there, four, five tons of molten iron. Then these men would prepare everyday, they would make the molds for the next day for these pipes. The molds were cast-iron and the cores were from clay.*

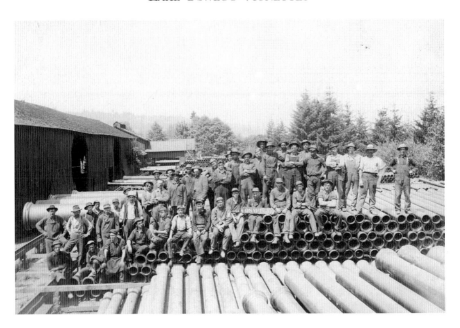

Oswego Pipe Foundry workers about 1915. *Photograph courtesy of Lake Oswego Public Library.*

The clay to which Blanken refers came from the Duck Pond—in other words, Lakewood Bay. After a few hours, the iron was cool enough to remove the pipe from the molds, the mud was hammered off and the pipe was tested for quality. In 1972, Earl Faucette said, "Lots of people don't know that those old cast-iron pipes are still in there and doing duty yet [between Bull Run and Portland]. I suppose they will be there when Gabriel blows his horn." The pipe foundry discontinued operation in 1928.

MAKING LIGHT OF SUCKER CREEK

The first white settlers in Oswego relied on water as a source of power. Albert Alonzo Durham located his sawmill on Sucker Creek in 1850 for this reason. Almost forty years later, the first electrical current in the country was harnessed and transmitted from Oregon City to Portland in 1889. Electricity soon lit the way out of the "dark ages" of candles, lanterns and gaslights.

The Oregon Iron & Steel Company owned the water rights and the dam on Sucker Creek. To retain these rights, water needed to be used for industrial purposes. Iron production had ceased, so the company seized on the need

for a local source of electricity to retain its water rights. Construction of the powerhouse began in 1909 and was completed in 1911. Two penstocks, or enclosed pipes, five feet in diameter, were built of Douglas fir to carry water to the generator. Power was needed for Oswego's industrial, commercial and residential customers.

In 1911, the Oswego Lake Water Light & Power Company is named in tax records. It was incorporated in 1915 as an Oregon Iron & Steel Company affiliate.

During World War II, the power plant was staffed around the clock. William (Billy) Banks served as the night shift operator. He had a potbelly stove for heat and a wooden chair named Sparky that was decorated with glass electrical insulators on all four legs. When the daytime operator quit to work in the shipyards, Billy's wife, Claire, took over the shift.

The Lake Oswego Corporation purchased the power plant in 1960. Due to the deed restriction requiring industrial use to retain water rights, the historic

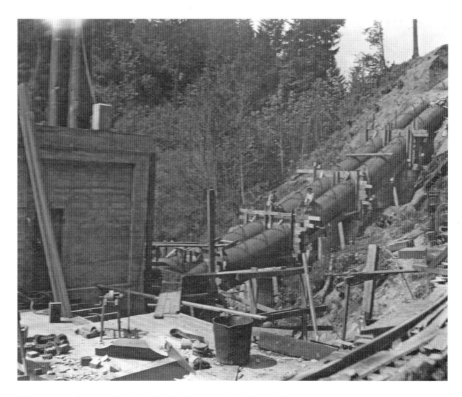

The power plant on Sucker Creek (Oswego Creek) and the penstocks under construction. *Photograph courtesy of Lake Oswego Corporation.*

powerhouse continues to generate a small amount of electricity to this day. The double penstocks were replaced by a single penstock after a flood blew out the top of the powerhouse. The original Pelton wheel water turbine, first patented in 1889, and the Westinghouse generator are still in place.

Walking the Plank

Sidewalks, when they existed in the late nineteenth century, were made of wooden planks, and lumber for this purpose was milled in Oswego. By 1865, John Corse Trullinger had acquired and modernized Albert Alonzo Durham's sawmill on Sucker Creek, now Oswego Creek. Trullinger's new business was named the Oswego Milling Company. The primary product was sidewalk lumber for Portland and Oswego streets.

Even well into the twentieth century, Edna Farmer, in *In Their Own Words*, remembered Oswego in the 1920s: "When I was a girl, they had board sidewalks all along here. You had to go up the steps as the sidewalks themselves were three or four feet up off the main road. You had to walk clear down the whole length of the walk and then go down the steps at the other end." Another resident, Fern Poff, recalled, "At that time, dirt roads and wooden sidewalks were all that was available in what is now known as downtown Lake Oswego."

Wooden sidewalks line the south side of B Avenue. The Koehler home, the first building on the right, is still standing. *Photograph courtesy of Lake Oswego Public Library.*

CEMENTING BAD RELATIONS

Cement manufacturing was a major industry in Oswego. Plant construction began in 1909, but it wasn't until 1916 that it produced Oregon's first barrel of cement. This delay was due to financial difficulties, as well as contentious and litigious beginnings.

The Oregon Portland Cement Company at Oswego was the official name of the business that was located where the Oswego Pointe apartments stand today. "Portland" is a type of cement, and it is not named after Portland, Oregon. Aman Moore was brought from Salt Lake City to build and run the largely Mormon-financed operation, and he did everything but cement good relations with the community.

Moore was unpopular because, instead of using local labor to build the plant, he brought in African American workers, he was sued for questionable business practices and he caused a riot. In 1911, Moore fenced off Furnace Street in an effort to claim possession of the land on the cement company's behalf, and this action inspired two hundred townspeople to rebel. George Prosser, a prominent member of the community, was one of the cooler heads that prevailed. Prosser was instrumental in getting a court order for removal of the fence.

That same year, 1911, John Bickner sued Moore and the cement company over a land dispute. Bickner and his son Henry met with Moore in his office. Things got out of hand, and a shovel, a plank and a club were employed during the "discussions." Both the elder Bickner, then seventy-one years old, and Moore received head injuries, and a diamond ring went missing in the ruckus. Bickner filed a lawsuit for $10,000 in damages against Moore.

Eventually, Robert Pim Butchart took control of the company, and he brought Lawrence Creighton Newlands from British Columbia to serve as vice-president of the company. Under Newlands' direction, the Oswego Portland Cement Company began to employ local laborers. A clubhouse was built where the Albertsons' grocery store now stands. It was opened to the community for dances, meetings and entertainment. This building later became the Dahl House restaurant and then Chapel by the Lake mortuary before being demolished for a shopping center. Cement production ceased in 1981; all other operations were discontinued in 1986, and the plant was demolished in 1987.

FISH IN SHIPS

W.H. Auden declared that he would love "until the salmon sing in the street." Although they didn't make it to the streets of Oswego, salmon all but sang in the Willamette River at the turn of the twentieth century.

In 1972, Ed Twining was interviewed for the oral history collection *In Their Own Words*. Ed remembered, from his days growing up in Glenmorrie:

> *That sand bar* [at the mouth of Sucker Creek] *was where all the fishermen always came, gill netting in the spring. I knew all the people in there: Tom and Ed Erickson, and Ike Austin and his two sons, old Pokewood. Slim Charlie was a trader, and all that gang fished there, and they'd come in with boat loads of big salmon. We'd fish at night, and we thought that was big stuff. It was, too.*

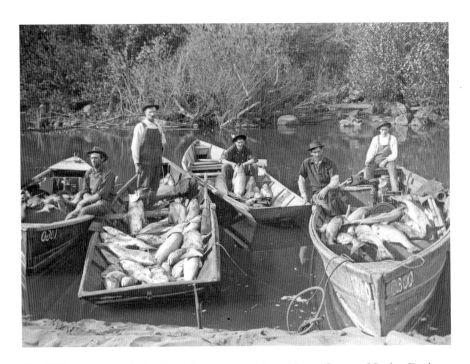

This 1905 photograph of a boatload of salmon was taken at the confluence of Sucker Creek (Oswego Creek) and the Willamette River. *Photograph courtesy of Lake Oswego Public Library.*

Giving Logs a Lift

Old River Road was once the main road from Oswego to Linn City (now West Linn). It crossed Sucker Creek by way of a covered bridge near where the footbridge in George Rogers Park now stands. The fort-like cement structure on the riverbank was built by the Crown-Willamette Paper Company to hoist logs out of the Willamette River. To avoid passing logs through the Willamette Falls Locks, they would be lifted onto rail cars for transport to the paper mill.

Fir, spruce, hemlock, cedar and other logs were put in the Columbia River near Astoria and brought in booms—log rafts—by stern-wheelers to Oswego. A crew of a dozen men worked at what was officially named the Oswego Log Loading Station. Logs were sorted into loads and then lifted up the bank with the help of a motor.

Roy Headrick, who started working on the hoist in 1916, recalled, "We loaded six [Southern Pacific flatbed rail] cars. The train took the six cars to Oregon City [both sides of the river used to be referred to as Oregon City] and brought back empties to load while they were gone. A train ran six times a day, and we loaded thirty-six cars." The train ran on a trestle adjacent to the hoist. A house built about 1915 by the Crown-Willamette Paper Company sits on the hill above the hoist. The log hoist manager, Ruben W. Confer, occupied

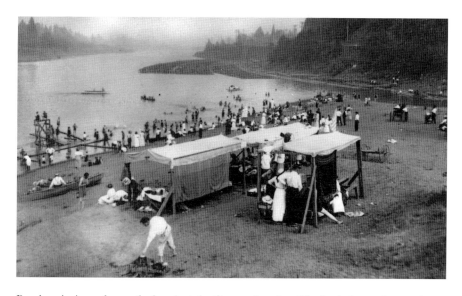

People enjoying a day on the beach at the Oswego Landing. The log hoist can be seen in the background. *Photograph courtesy of Martin Goebel.*

it, and it's erroneously called the "Tug Master's House." The log hoist ran from 1915 until 1933, when the Southern Pacific abandoned the operation.

One very cold winter, the Willamette River froze about two and a half feet deep, and the logs were stuck in the ice. According to Lyle Arthur Baker, John Erickson decided "to bullet-crack the ice. So he put one hundred and fifty sticks of dynamite on top of the ice. Oh, brother, he smashed it up all right. He cracked the ice halfway to Oregon City."

The concrete walls and broken windows on top of the hoist are the ruins, not of Erickson's dynamite, but of an abandoned attempt to build a residence atop the old structure. Covered with graffiti and ivy, it now stands as a neglected monument to Oswego's industrial heritage.

SELLING WATER TO LOS ANGELES

Oswego's Sucker Lake was once considered a possible source of Portland's water supply, but the Portland Water Company decided instead to build the Palatine Hill Pumping Station on the Willamette's riverbank in modern Dunthorpe. When the station was completed in 1883, water was simply pumped out of the then polluted river and delivered to users' taps, resulting in many deaths from typhoid fever. Clean, pure water piped from the Bull Run Watershed on Mount Hood replaced the pumping station as Portland's major water source in 1895.

In Oswego, water was mostly taken from wells and springs. Lillian Webster recalled, "There was a spring down not too far from the foundry where Oswego used to get its water, and Dad could see that they didn't have enough. They had no water to fight fires." Some townspeople, including Webster's father and Lawrence Creighton Newlands, the Oregon Portland Cement Company's vice-president, advocated getting Bull Run water for Oswego. They were ultimately successful, but residents complained for years about the increased taxes to pay for this service. Karl Faucette recalled:

> *I think some of the first, if not the very first, pipes that were laid between Bull Run Lake, up near Mount Hood, and Portland were used to bring the water down to Portland. I think there were two pipes, and they supplied Portland with all the water they needed at that time. The city was between eighty and ninety thousand [people].*

Lillian Webster also commented:

> *Do you remember when the Olympic Games were played in Los Angeles [in 1932]? Well, I went to the games in Los Angeles, and while I was there, they were selling Bull Run water on the streets in huge containers. Los Angeles had the worst water in the world. They were selling Bull Run water.*

HITTING THE BRICKS

In 1957, it was reported that "excavating for the Lake Oswego Village [the shopping center on the northeast corner of State Street and North Shore Road] now under construction…has turned up remnants of Oswego's old brickyard." The article goes on to say that David Long arrived in Oswego in 1884, and the brickyard was in operation at that time. A man named William (Billy) E. Wells was reportedly the proprietor, but this cannot be verified because all the U.S. census records for 1890 were destroyed in a fire in 1921.

Clay deposits came from the hillside near Leonard Street and the Duck Pond (Lakewood Bay). The brick was used to build the second furnace and its charcoal kilns. Karl Faucette remembered, "The coke ovens were great half globes built of brick. Some of the finest brickwork I ever saw went into those things. The man that laid those bricks was an artist." He added,

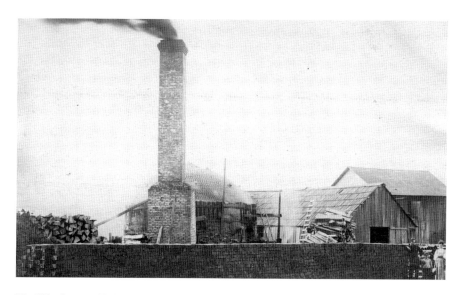

It's difficult to verify, but this turn-of-the-century photograph may depict the Oswego brickyard. *Photograph courtesy of the Lake Oswego Preservation Society.*

"There were twenty-four of those things [an 1888 article in the *West Shore* magazine notes that there were originally thirty-six brick beehive-style kilns], and it was a beautiful sight to see all these rows. I counted them, and there was an even two dozen. I never ceased to look at them and admire them."

When the second furnace and the kilns were demolished, some of the bricks were used in 1908 to build the Christie School. Cornelius DeBauw recalled, "When they [the Sisters of the Holy Names] bought the farm, they also bought the brick from the kilns where we used to make charcoal for the furnaces. They tore that down, and then they took the brick, and they hauled them up there and used them on the Christie Home." Mrs. George Rogers also recollected that "our house on Wilbur Street [in the Old Town neighborhood] is built from brick from the second old furnace." By 1900, the brick operation had shut down, and the site had been turned into a baseball field.

LIGHTING FIRE WITH FIR

There were once two iron furnaces in Oswego, and they had insatiable appetites for Douglas fir trees. Of course, the trees first had to be converted to charcoal. In the nineteenth century, Chinese laborers were hired to fell the trees. Once the wood was cut, the job became even more dangerous. Colliers, as charcoal makers were known, carefully stacked the four-foot billets of wood on end around a tall pole in the center of a level clearing. The wood was stacked in three tiers so the finished mound stood about twelve feet high and thirty feet wide. A covering of dirt and leaves was used to reduce the oxygen supply to prevent the pile from suddenly igniting and sending all the hard work up in flames. Dropping hot coals down a center hole lighted the pile.

Charcoal "pits," as they were called, were scattered over the countryside from Tryon Creek to West Linn. The wood slowly smoldered for about two weeks, tended night and day by the collier, as it was transformed into charcoal. Colliers had to climb on the mound to check for soft spots, and there was always the possibility that they could fall through.

This labor-intensive and risky method was used to make charcoal in Oswego until 1885. After 1888, the iron company made charcoal in brick kilns. There is no known photograph of charcoal pits in Oswego. Will Pomeroy notes in his diary entry for July 3, 1883, "It has been smoky for 3 days or more. Hot." Charcoal burning created the smoke to which Will refers. Oswego's iron furnaces were also tended around the clock, and they subsisted on a steady diet of charcoal, along with limestone and iron ore.

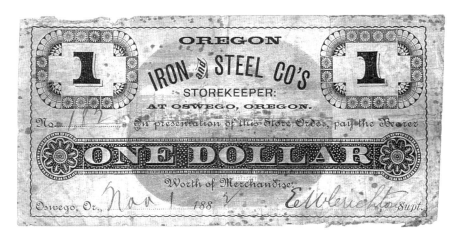

Scrip was issued to employees by the Oregon Iron & Steel Company. *Image courtesy of Lake Oswego Public Library.*

WHAT THE COMPANY HAD IN STORE

The Oregon Iron & Steel Company developed Oswego into a company town. It operated a company store, built houses for workers and paid employees in scrip. According to a *Portland Evening Telegram* article published in 1925, this scrip circulated freely in Oswego and throughout Oregon and was "accepted as freely as cash in any ordinary business transaction, except for payment of taxes." Payrolls indicated each employee's debit for company store purchases against his wages. In 1867, wages ranged from seventy-five cents a day for a waiter to five dollars per day for a mason.

George D. Wilbur, who was under contract to supervise the construction of the first iron furnace, returned to Connecticut upon the job's completion. A receipt for one of the final payments to Wilbur, dated March 11, 1867, for $540, specifically notes that the payment was in "currency." The Legal Tender Act of 1862 was enacted to allow Congress to issue paper money in an effort to pay for the cost of the Civil War without raising taxes. Many people were skeptical of "greenbacks," and wages often were paid in gold coin.

EARTHSHAKING NEWS

In 1888, the second, more modern ironworks was built north of the original furnace in the present-day Foothills area. The opening of this, and the associated pipe foundry, created the need for convenient and affordable

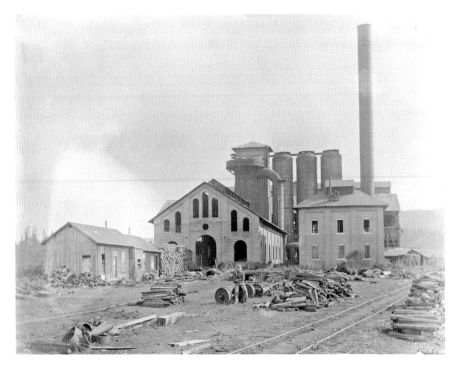

The second iron furnace, demolished in 1929, was located in today's Foothills area. *Photograph courtesy of Lake Oswego Public Library.*

workers' housing, and thus the First Addition neighborhood was developed. The furnace operated until 1894 and the pipe foundry until 1928. The second iron furnace stood idle for thirty-five years, until it was dismantled in 1929. A newspaper account reported:

> *Wreckers leveled an Oswego riverfront landmark yesterday noon, when they brought down the 160-foot chimney of the old iron works with a crash that shook surrounding territory. The base had previously been cut with acetylene torches, and a mighty pull by a steam engine on heavy cables fastened to its framework brought the huge chimney down.*

GETTING AROUND TOWN
Transportation

- In April 1929, a plane lost power and crash-landed into trees one block south of A Avenue on Fourth Street. The aircraft landed right side up, and the pilot and passenger were uninjured.
- Two steamships, the *Minnehaha* and the *Henrietta*, ferried cargo and passengers across Sucker Lake in the late 1800s.
- In a 1928 newspaper article, it was reported, "Moonshine mixed with gas caused auto wreck." One wonders where that driver tanked up!

A FERRY TALE

Alphonzo Boone, grandson of frontiersman Daniel Boone, and his family were among the pioneers headed west to a new Eden in 1846. Along the Oregon Trail, some members split off in search of a shortcut to California. This ill-fated group is now known as the Donner Party. Soon after arriving in Oregon, Jesse Van Bibber Boone, Daniel Boone's great-grandson, laid out a path from south of present-day Wilsonville to southwest Portland. It's hardly surprising that the path crossed the Willamette at the exact spot where Boone had established a ferry crossing in 1847. The ferry was one of the earliest in Oregon. Today, the path Boone made is known as Boones Ferry Road. About four miles of the road pass through Lake Oswego. There is a stone marker at the north end of Boones Ferry Road where it meets Taylors Ferry Road, placed by the Boone Family Association in 1937.

Jesse Boone ran the ferry for twenty-six years, until Jacob Engle, a neighbor, murdered him during a dispute over access to the shore, a right that Boone had licensed and used for over two decades. Jesse Biber Boone was buried in the Butteville Cemetery in Marion County. His widow, Elizabeth, petitioned and won the legal right to continue to use the landing. The ferry operated for 107 years, until 1954, when the Boone Bridge was built across the Willamette. During its years in operation, it carried thousands of pedestrians, cows, horses, buggies and cars across the river.

CORN FLAKES ROCKET

Edna Bickner, a one-time Oswego Sunday school superintendent, was photographed in a corn flakes rocket. This photo captures Edna, dressed in a bonnet, ensconced in a contraption pieced together from discarded Kellogg's toasted corn flakes, Goldenrod and German American Coffee Company boxes, plus a wooden barrel. Was it for a parade? Or a Fourth of July celebration? Or perhaps a church fundraiser? Was it a rocket that was inspired by reading H.G. Wells or Jules Verne? We may never know the answer to this mystery.

Edna Bickner ensconced in her fantastic corn flakes contraption. *Photograph courtesy of Lake Oswego Public Library.*

Losing Steam

The local steamboat era lasted almost one hundred years. There were four landings on the Willamette River near Oswego. The Oswego Landing was situated at the confluence of the Willamette River and Sucker (now Oswego) Creek. Incredibly, it looks today much like it did over a century ago. Herbert Letcher Nelson recalled, "I remember going down there [Oswego Landing] and holding up my hand to a big steamboat coming up the river. They would put down the gangplank; I would walk up on deck to where the purser was standing and hand him a quarter, which was the price for a ride to Oregon City." The only other way to reach Oregon City in those days was on horseback or by walking five miles.

The Oswego Iron Works Landing, near the second iron furnace, was located in what is now the Foothills area. The Elk Rock Landing, near Tryon Creek, connected to the narrow-gauge railroad's terminus before the trestle was built around Elk Rock.

The fourth landing was Walling's Landing, also known as Morey's Landing, south of Oswego. Parker Farnsworth Morey and his wife, Clara, owned the land that is now the Glenmorrie neighborhood. Parker Farnsworth Morey, president of the company that became Portland General Electric, would

A steamboat cruising on the Willamette River opposite the Oswego Landing. *Photograph courtesy of Lake Oswego Public Library.*

offload trees from around the world to adorn their estate. The Morey family also used the landing when they left their eleven-bedroom "shack" to travel to their other homes in Oregon City or Ilwaco, Washington. Often, the family cow was taken along as one of the passengers so the children would have fresh milk.

OSWEGO TAKES OFF

The Amart private airstrip once existed in the area that is now part of the Westlake neighborhood. It was the only airport in Oswego. Arthur Fields, a prominent automobile dealer, constructed the airstrip and hanger amid hayfields in the mid-1950s. The name "Amart" was a combination of "Am" in honor of Fields's wife, Amy, and "Art" for "Arthur." Unfortunately, tragedy struck the family when the aircraft's tanks were filled with the wrong fuel; an explosion ensued and Fields's son, Philip, and grandson, Terrence, died in the crash upon takeoff from the Troutdale airport.

Fields founded Arthur L. Fields Chevrolet Company in Portland, and he was an active civic leader. He served as Portland Rose Festival president and Community Chest president, and he was honored as First Citizen of Portland in 1936.

The purchase of land by Mr. and Mrs. Fields in the early 1950s began a slow process of development in the city's northwest corner. Prior to that time, agrarian pioneers such as the Kruse, Stone and Wilmot families farmed the majority of land in this area.

Upon Mr. Fields's death in 1969, much of his land was bequeathed to Lewis & Clark College, which in turn sold it to the Church of Latter-day Saints. Mormon leaders ultimately decided to develop the land, and the Westlake subdivision and the Centrepointe commercial development were the result. Amy and Arthur Fields's house still stands on Fosberg Road in the Holly Orchard neighborhood.

ONE-TRACK MINDS

On May 31, 1918, two Southern Pacific freight trains collided head-on between Goodin Station in Lake Grove and the Oswego Depot. Many crew members were able to jump to safety. Miraculously, there was only one fatality: Willard Knight, the engineer of the train that had the right

Alda Rosentreter standing in front of the head-on train wreck. *Photograph courtesy of Lake Oswego Public Library.*

of way. According to one account, wrecked train cars were piled up like kindling. Neighboring farmers thought that the sound of the impact was a big dynamite explosion. The *Oregonian* reported, "Members of the wrecking crew declared it to be the worst wreck in their experience."

The cause was determined to be the failure of men on train 231 to observe an order requiring them to wait at Oswego for train 234. The trains were traveling at approximately fifteen to twenty miles an hour, and trainmen could not see the opposing engine until they were only three hundred feet apart.

PAVING THE WAY

Today, driving down Highway 43, also known as Macadam Boulevard, without a thought beyond a possible traffic backup or what's for dinner, it's hard to imagine that this was once an arduous journey. Dirt roads are often either dusty or muddy, and in the days before pavement, logs were used to help alleviate this problem. Logs were laid down side by side, perpendicular to the flow of traffic, to create "corduroy" roads. These ribs created a bumpy ride at best and a hazard to horses when logs shifted.

When corduroy roads were replaced with paving, Macadam Boulevard was the first road of its kind in Oregon. In 1863, prominent Portland investors formed the Macadamized Road Company with the intent of building a toll road between Portland and Taylor's ferry service across the Willamette River. Several of the investors owned property in Riverwood (now Dunthorpe), so the road was extended south.

The word "macadam" is derived from John Loudon McAdam (1756–1836), a Scottish engineer who pioneered this type of road construction about 1820. The size of the stones in each layer of the road surface was key to McAdam's method. The larger hand-broken stones formed the base layer, and the smaller ones were used for the top layer. Compaction caused the layers to lock together. It is said that a workman could check the size by seeing if the stone would fit in his mouth.

A later innovation was to fill gaps in the surface with a mixture of stone dust and water. This was known as water-bound macadam, and roads constructed in this manner were described as "macadamized." Once motor vehicles took the place of horse-drawn vehicles, clouds of dust became a serious problem. To settle the dust, tar was sprayed on the road surface to create "tar-bound macadam" or "tarmac."

PLAN 9 FROM OUTER OSWEGO

For some visitors, Lake Oswego is out of this world. According to various websites, extraterrestrial guests have been sighted in George Rogers Park, Mountain Park, Hazelia Dog Park and, in one non-park-related sighting, over an eyewitness's garage. Lights on their UFOs reportedly run the spectrum from bluish green, a blue glow with red and green lights, red/orange, black, whitish and amber to peach-colored and more. Ships were described as the classic saucer, as well as triangular, bulbous, hang glider like and balloon like. Some UFOs even reportedly changed shape in flight.

The crafts, according to witnesses, wobbled, hovered or rotated in the sky. Sighting times spanned from early morning to late at night, and atmospheric conditions varied. Responses from humans who remained on the ground ranged from telepathic communication with the ship's crew to inexplicable and uncontrollable happiness and giggles. A dog involved in one incident was reportedly unfazed and remained completely silent.

ELECTRIC TRAINS FOR CHRISTMAS

Just after Christmas, on January 17, 1914, interurban electric trains were set to run from Portland to Oswego and beyond. The shiny fire engine red steel cars were nicknamed the "Red Electric," a name that stuck in spite of the fact that the "Webfoot Route" was selected as the winner in the Southern Pacific's naming contest. As Nellie Kyle recalled in a 1982 *Lake Oswego Review* interview, "The Red Electrics were a beautiful sight when they first arrived that January [1914]. Before the electrics, noisy steam trains spewed soot and cinders onto the ladies' white starched lace bodices." The Pullman-built cars had plush green upholstery, and the interior was finished with mahogany trim. This transportation option brought a new mobility to Oregon's population and facilitated development of previously remote areas such as Lake Grove. The fare for the thirty-minute trip between Portland and Lake Grove was ten cents. In fact, the earliest use of the name "Lake Grove" appears to be a 1914 reference to the Red Electric station by that name.

On the inaugural run through the Willamette Valley, Mary Goodall, in *Oregon's Iron Dream*, relates, "At one valley town onion growers gave each passenger a sample of their crop, the generosity brought tears to the eyes of the grateful passengers!"

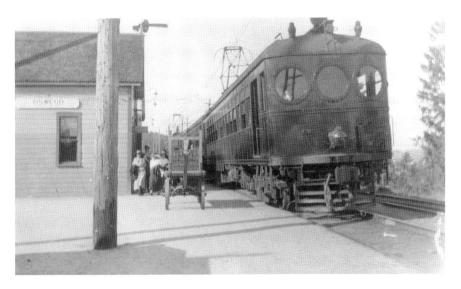

Passengers disembarking from a Red Electric train at the Oswego Depot. *Photograph courtesy of Lake Oswego Public Library.*

The Red Electric's heyday lasted only fifteen years before the automobile supplanted it. The Oswego line was one of the last to be abandoned, and all service was discontinued in 1929. This extensive mass-transit system has yet to be rivaled.

Claire as a Bell

A stern-wheeler named *Claire* plied the Willamette River from 1918 to 1952 and made many stops at landings in Oswego. The 160-foot *Claire*, like other steamships on the river, was propelled by a single paddle wheel along its stern. The wheel was powered by a high-pressure steam engine. In 1952, the steamer was retired from service in Western Transportation's fleet. The ship was piloted to Champoeg State Park, where it was converted to a carpenter's shop. Bob Potter of the Western Transportation Company said, "I hated to see that it was made into a carpenter's shop. Those old boats were really a treasure." Another old-timer, Frank Yount, who worked on steamships for nearly fifty years, said, "That [the *Claire*] was my favorite boat." Oregon college students also used the ship in a film entitled *They Blew for Every Landing*.

In memory of the steamer *Claire*, the Sternwheeler Men's Association mounted the ship's fog bell, a piece of local maritime history, on a pedestal with a plaque in George Rogers Park. In 1985, thieves hacked the bell off its pedestal, but it was recovered and has been in storage ever since. At the time of the theft, it was one of only a few historic markers in Lake Oswego.

7

BUILT TO LAST

Architecture

DID YOU KNOW?

- Oswego iron was used to build San Francisco's city hall. During the earthquake of 1906, the building collapsed, but the iron framework remained.
- In October 1926, thousands of visitors toured the Brixtile model house on Iron Mountain Boulevard. "The house of brick and tile" designed by architect Harold W. Doty was touted as an "exposition of refinement."
- Some of the stone used to build Portland's original Morrison Street Bridge in 1887 was quarried in Oswego.

VENICE COMES TO TOWN

In 1936, Italian-style cabanas were built on Lakewood Bay as exclusive rental properties. Oswego's major real estate developer, the Ladd Estate Company, enforced deed restrictions in their districts that prevented rentals. Paul C. Murphy, the company's president, was inspired by a trip to Italy and decided that the company would build its own rental properties. These units were high-end and architect-designed, in keeping with Murphy's vision for an elite residential district.

Architect Richard Sundeleaf was commissioned; the resulting cabanas were designed in the International style and built on piers over the water. The *Oswego Review* reported, "The houseboats are realistic, even to the gangplanks and anchor lines. The houseboats, 10 in number, represent a

total outlay of between $25,000 and $30,000." These amounts would be comparable to $388,000 to $466,000 in 2012 dollars.

Among the cabanas' residents in the 1940s was Mario Bisio Sr., who founded the Wilson Shirt Shop in 1937. Bisio went on to start Portland's exclusive Mario's clothing store and ran it in partnership with his son. The cabanas, now significantly altered, still stand on Lakewood Bay in today's Evergreen neighborhood.

THE FORTY-EIGHT-HOUR HOUSE

It typically takes several months to build a house, but in Oswego, a six-room, two-story, move-in-ready house was constructed in just forty-eight hours. Green Road, which used to be off South Shore Boulevard, was the site of such a building feat in the fall of 1940. Paul Fuller Murphy, the son of the visionary developer Paul Cole Murphy, sponsored this publicity stunt, which took place only after Murphy secured an exclusive marketing agreement and created a team to handle sales of Johnson-Bilt prefabricated homes.

The first of these popular homes was built on Ash Street without much fanfare. Its success led to the building of a Dutch Colonial–style home that featured three bedrooms, two bathrooms, a kitchen, a dining room, a living room and a garage. The outside walls and interior partitions were assembled at the C.D. Johnson Lumber factory in Toledo, Oregon, and transported to Oswego on a heavy-duty trailer. According to the newspaper announcement, it was expected that within one eight-hour working day, exterior and interior walls would be erected, complete with doors and windows. Twenty-four hours later, the structure would be ready for occupancy. The public was, not surprisingly, invited to watch the "show."

WE'VE GOT THE BRIDGES COVERED

Although covered bridges are now picturesque, bordering on romantic, the covering of wooden bridges was once a practical undertaking to prolong their usefulness by protecting the wood from the ravages of time and the elements. Oswego had at least three covered bridges.

One bridge spanned Sucker Creek (now Oswego Creek) near the site of the current footbridge. Elizabeth Pettinger recalled, "Over the covered bridge went all the west side traffic, light as it was, from Portland to Oregon City.

The road on Durham Street, leading down over the hill, across the covered bridge and along the river road was the only direct highway there was."

Another covered bridge extended across Tryon Creek. Herbert Nelson said:

> *I remember John Confer because he lived down by the river. His claim is down by the mouth of Tryon Creek on the north side. Someone by the name of Stampfer moved in there a number of years ago for a time, and so they call it the Stampfer Road instead of the Confer Road that runs down there. He might have built the covered bridge over Tryon Creek, because he lived right there.*

The covered bridge on what is today's McVey Avenue sported a "Walk Your Horses" sign. Arthur Jones recalled:

> *Below the dam was a bridge, a covered bridge, over which you would walk your horses. There was a twenty-dollar fine if you didn't walk your horses. And, it was a rather rickety bridge. I thought to myself since that that probably was a rather wise proviso, although people didn't always walk their horses, I can tell you.*

Four women and a child on the upper Sucker Creek (Oswego Creek) Bridge in 1908 where the bridge on McVey Avenue is today. Note the prominent "Walk Your Horses" sign. *Photograph courtesy R.W. Helbock, La Posta Publications.*

Storrs, Houses and a School

John Storrs was an accomplished and nationally recognized architect who designed many of Oregon's iconic buildings. He began to practice in Oregon in 1954, and his work includes Catlin Gabel School, the Western Forestry Center, Sokol-Blosser winery and the Oregon School of Arts and Craft. For the developer John Gray, Storrs also converted the former B.P. Johns furniture factory into Johns Landing, and he designed Salishan Lodge and Sunriver Resort. In 1951, prior to Storrs's move to Oregon, noted architect Van Evera Bailey designed John Gray's Oswego home, at 1345 Chandler Road, which has been demolished.

Storrs was unabashedly controversial, and he was a larger-than-life figure who commanded attention upon entering a room. Scorn and praise coexisted in both his supporters and his detractors.

In Lake Oswego, Storrs designed Lakeridge High School, which opened in 1971. He took an unconventional approach as a preliminary to designing the school. Storrs invited students to his home and talked with them about their thoughts about how a school should look and function. The school was remodeled extensively and expanded in 2003. Storrs also designed at least two homes in Lake Oswego, both mid-century-modern designs dating from 1959, at 245 Chandler Place and 983 Lake Front Road. Storrs also designed two homes in Skylands at 309 Southwest Skyland Drive and 1415 South Skyland Drive.

Storrs was an accomplished chef, and his son, Leather Storrs, is currently a celebrated Portland chef and restaurateur.

The $6.4 Million Question

Whether to build an exclusive resort hotel in Oswego was a question being posed in 1930. Paul C. Murphy, the Ladd Estate Company's visionary developer, made most of his dreams for Oswego come true. He was instrumental in building the Oswego Lake Country Club, the polo field, the Lake Oswego Hunt, and bridle paths on what is now called Iron Mountain. These resort-like amenities were designed in keeping with the company's sales slogan: "Live where you play."

Evidently, Paul C. Murphy also envisioned Oswego as a vacation destination. In 1930, his plan was to build a half-million-dollar resort hotel (that amount in 2012 dollars is approximately $6.4 million). It was to be

located south of Ladd Street and east of present-day Highway 43, essentially where the ball fields in George Rogers Park are today. Situated between the Willamette River and Oswego Lake, it was thought to be an ideal location. A petition was circulated to vacate certain streets and alleys to make way for the development. Evidently, the idea had been in the works for a number of years. An April 3, 1930 article states, "When the hotel will be built is a matter of conjecture. A report is in circulation that stock is now being sold in the enterprise and that sufficient financing has been assured to make certain its erection during the coming summer."

For better or for worse, the hotel never got off the ground. It was one of the few Ladd Estate Company projects that did not become a reality. Funding for the project and guests for the luxury hotel were probably scarce in the face of the Great Depression that gripped the country during those times.

ALL-ELECTRIC HOME

The term "all-electric" typically applies to the type of energy a home uses. In this case, the homes were created from a building that originally housed electrical generators that powered the Southern Pacific Red Electric trains. Oswego was the site of the most expensive substation in the system, built at a cost of $9,000. This circa 1912 substation still stands on Lakewood Bay. After the Red Electric trains stopped running in 1929, the building was adapted for the looms of the Oswego Weavers' necktie factory.

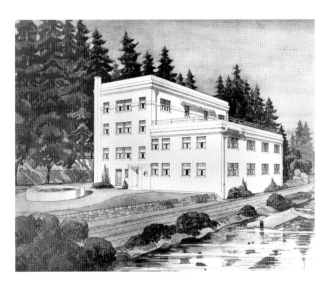

An architectural drawing by Barrett & Logan of the apartment conversion in the 1940s. This was the second adaptive reuse of the Southern Pacific's Red Electric substation building. *Image courtesy of the Lake Oswego Preservation Society.*

The housing shortage during World War II prompted the enlargement and adaptation of the building into apartments under the auspices of the U.S. National Housing Agency Homes Use Program. The architectural firm Barrett & Logan was hired for the work. The building is currently on its fourth reincarnation as condominiums.

BLAST FROM THE PAST

Miraculously, the basalt masonry of Oswego's first iron blast furnace has survived for well over a century. It has narrowly escaped the natural ravages of weather, vegetation and time, plus the human threats of dynamite, gunite (a spray-on form of concrete), neglect and the suggestion that it be used as a base for a statue of Samuel L. Simpson, Oregon's first poet laureate.

On January 26, 1932, an unsung hero sent the following letter to the editor of the *Oswego Review*:

> *I would like to ask why Oswego's Monument to its Pioneers is not taken seriously. Today as I passed by it I saw mostly brush and weeds growing around it. I am referring to the stove furnace down by the river. In a few years more it will be the center attraction of a jungle…Why could not a few more dollars be spent to fix up around it and put a sign on the highways to point out to the many hundreds of tourists who are out to see the many attractions of the various cities they visit? Perhaps if a few tourists would stop to see it they would remember to buy a few necessities and leave a few tourist dollars in Oswego. Why could not a history of its origin be written and placed in a frame so all could know what it was? Pretty soon the last old timer will be placed under the sod and the only history that could be written will be from hear say. Would it not be nice if it could be placed on the map as it once was? Why could not one of the various organizations take this matter up and see it through, or should it be forgotten and just be called a pile of rocks? I wonder why? What would you do, Mr. Editor?*

Over the decades, there has been a succession of prominent champions intent on saving the 1866 furnace. These include George Rogers in the 1940s, Mary Goodall in the 1950s and the Lake Oswego Junior Historical Society members in the 1960s who placed "Save the Stack" donation boxes at local merchants. In recent times, Susanna Campbell Kuo dedicated years to spearheading efforts to restore the edifice. Thankfully, these collective

efforts have come to fruition. Not only has the furnace been saved, but also a careful preservation and stabilization project was completed in 2010, paid for in part by a "Save America's Treasures" grant and the local hotel/motel tax. Interpretive panels ensure that its significance will be understood by future generations. The influx of "tourist dollars" envisioned by the anonymous writer in 1932 can now be realized. The only surviving blast furnace west of the Rockies is Lake Oswego's major heritage tourism attraction. One would have to travel over one thousand miles to see another.

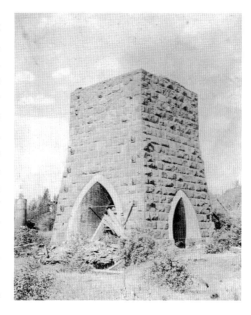

The abandoned blast furnace photographed on September 8, 1899. The furnace was neglected for over 120 years before finally being preserved and interpreted. *Photograph courtesy of Norm Gholston.*

DEMOLITION DERBY

Pietro Belluschi, born in Ancona, Italy, and educated in Rome, was dean of Architecture at the Massachusetts Institute of Technology (MIT) School of Architecture and Planning from 1951 to 1965. He was also the renowned architect of the Julliard School of Music in New York City, St. Mary's Cathedral in San Francisco, the Portland Art Museum and many other significant buildings. Belluschi immigrated to Portland as a young man and apprenticed at the firm of A.E. Doyle. In a career spanning fifty years, he designed over one thousand buildings. Belluschi is credited, along with John Yeon, with creating the Northwest style of architecture.

The world-famous Belluschi designed at least three buildings in Lake Oswego: a school, a house and a church. Of the three, one remains in place, another is slated for demolition and the third, through private efforts, has been deconstructed and stored for eventual relocation. The Sacred Heart (now Our Lady of the Lake) School, designed by Belluschi in 1949, will be demolished to make way for a new school building once

the funds can be raised for its replacement. Current plans do not call for deconstruction, so all of the salvageable architectural elements might be trucked to a landfill.

The Griffith House, designed in 1949 for Arthur and Lucy Griffith, was originally located on the corner of Pine Valley Road and Iron Mountain Boulevard. The house was a small, residential jewel sited both to blend in with and to take advantage of the wooded setting. Through the preservation efforts of Tim Mather, president of MCM Construction, the house has been saved and is on track to be reconstructed on Lake Oswego's Marylhurst University campus.

At the age of ninety-one, Belluschi did the drawings for Our Savior's Lutheran Church on Country Club Road. The church was built in 1994, the same year that Belluschi passed away. This was the last of more than thirty churches Belluschi designed. The church is soon to be the only Belluschi building in Lake Oswego that remains on its original site.

The Sacred Heart School was renamed Our Lady of the Lake School in 1951. This school, one of only three buildings in Lake Oswego designed by the world-famous architect Pietro Belluschi, is slated for demolition. *Photograph courtesy of Lake Oswego Public Library.*

The Sucker Creek (Oswego Creek) Bridge under construction in 1920. Conde B. McCullough, Oregon's master bridge builder, designed it. *Photograph courtesy of Lake Oswego Public Library.*

BUILDING BRIDGES

The covered bridge over Sucker Creek collapsed after fifty years. According to a newspaper account, "About seven o'clock a.m. Wednesday morning the bridge decided it had fulfilled its duty and fell into the creek." In 1920, a new bridge designed by Conde Balcom McCullough took over this duty. McCullough had been appointed Oregon's state bridge engineer in 1919. The Sucker Creek (Oswego Creek) Bridge was his second major work for the Oregon Department of Transportation. In 1979, it was deemed eligible for the National Register of Historic Places. It was rendered ineligible for this distinction in 1982, when the bridge was significantly widened and altered with little regard for the original design.

McCullough's sensitivity to functionality and economics, as well as aesthetics, made him a nationally and internationally renowned bridge builder. McCullough once described his vision for the five coastal bridges he was to build as "jeweled clasps in a wonderful string of matched pearls." Over the span of his long career, he and his staff designed and built nearly six hundred bridges.

On the Streets Where We Live

Neighborhoods and Houses

Dɪᴅ ʏᴏᴜ ᴋɴᴏᴡ?

- Dunthorpe, Portland's unincorporated suburb, was once part of the Oswego Lake Country Club District. It was platted in 1916 and named after Elliot R. and Alta Corbett's home, Dunthorpe.
- Oswego iron was used for the ornate cast-iron façades that graced Portland's early buildings.
- The quaint house-shaped building with the brick chimney on the northwest corner of State Street and North Shore Road originally housed the 1925 Lakewood real estate sales office of the Ladd Estate Company.

An Electric Pig in the Kitchen

On February 24, 1935, it was reported in the *Oswego Review* that Harold Pierce Davidson and his wife, Leona, moved from one of the oldest houses in Old Town Oswego to their brand-new home on Lake Front Road. The home was equipped with all of the modern conveniences, including an "electric pig" for garbage disposal. For the time, this was an avant-garde appliance. Although the first garbage disposal was invented in 1927, the invention didn't gain widespread popularity in American homes until the 1970s and 1980s.

The intent of the building contractor, Ray Wason, was to provide unrestricted views from almost every part of the home. Wason came

The Davidson House, built in 1935 on Lake Front Road. The house, now demolished, was a rare example of the Streamline Moderne architectural style in Lake Oswego. *Photograph courtesy of the Lake Oswego Preservation Society.*

from Massachusetts, and his father was prominent in the field of concrete construction. The Streamline Moderne–style house was built of steel, glass and vibrated concrete. Vibrating was a technique used to remove air pockets from concrete slabs or units. This building material was appropriate for Davidson, an employee of the Oregon Portland Cement Company for forty years. The ship-like lines of the house fit the lakeside setting, and it was one of the few examples of this architectural style in Oswego.

On the interior, indirect lighting fixtures were used throughout the house. This is shielded up-lighting that is bounced off the ceiling, an innovation developed by Frank Lloyd Wright. The stair banister was made of stainless steel in a modernistic design. The corners of the rooms were rounded for style and easy cleaning. In fact, the house, it was said, "would delight any woman who cares for homemaking and housekeeping."

Sitting Pretty in Oswego Acres

A poetry contest is a unique way to promote real estate. In 1925, Oswego Acres developers faced stiff competition from the Ladd Estate Company, the largest real estate marketing firm in Oswego. Oswego Acres was located in Lake Grove, near the Ladd Estate Company's Rosewood development. To publicize the enterprise, the Oswego Acres developers held a limerick

contest. Limericks are a humorous verse consisting of five lines. The origin of limericks is obscure; it may or may not have something to do with the city in Ireland, but they appear to have been invented around the turn of the twentieth century.

First prize for completing the following limerick was a one-acre lot:

> *There was an old lady named Kitty,*
> *Who found great expense in the city,*
> *High taxes and rent,*
> *To escape them she went,*

Mrs. Clara B. Castle's winning submission for the final line was: "Where Oswego's home acres 'sit pretty.'"

A MEDIEVAL CASTLE WITH AN OSWEGO LAKE MOAT

Once upon a time in 1910, Danish immigrant Carl C. Jantzen and his partners, Roy and John Zehntbauer, founded the Portland Knitting Company, which manufactured sweaters, hosiery and jackets. That same year, a local rowing team member asked if they could make rowing trunks with an elastic rib stitch, which would stay up without a drawstring. This serendipitous request led to a swimsuit innovation, an automated circular knitting machine that was patented in 1921. The wealth this innovation generated enabled Jantzen to build a palatial English Tudor–style estate on what has become known as Jantzen Island in Oswego Lake. Jantzen paid $50,000 for the island, and Oswego Lake provided the natural "moat."

Work on the estate began in 1931, at the height of the Great Depression, motivated in part by providing work to the locally unemployed. According to a December 1930 newspaper account, the mansion was predicted to cost about $410,000 (about $5.8 million in 2012 dollars). Tommy Tomson, a landscape architect who later helped develop California's Palm Desert, designed the original gardens. The setting was perfect for showcasing Jantzen products, with swim competitions, bicycle boats and swim parties. There are three separate National Register of Historic Places designations for the Jantzen estate: the house designed by Charles Ertz, the boathouse designed by architect Richard Sundeleaf and the Sundeleaf-designed bridge.

Prior to Carl Jantzen's occupancy of the island in Oswego Lake, it was known as "Crazy Man's Island" for a recluse who inhabited it. Jantzen

The medieval-style stone boathouse designed by architect Richard Sundeleaf for the Carl C. Jantzen estate on Carneita Island (Jantzen Island). *Photograph courtesy of Hilary Mackenzie.*

named the island Carneita, a combination of the names of his children, Carl Jr. and Oneita. The owner after Jantzen was Harry K. Coffey, an insurance executive, and in 1956, the island was sold to Carl Halvorson, the developer of Mountain Park, Little Whale Cove in Depoe Bay and Black Butte Ranch in central Oregon. For a time, the island was called Halvorson Island. Jerry Stubblefield, founder of the Avia shoe company, has owned the island since 1987.

HINDU INVASION

Long before the Rashneeshees invaded Antelope, Oregon, Lake Grove residents were up in arms over the possibility of a religious sect in their midst. In October 1928, an article in the *Oregonian* claimed, "Lake Grove Stirred Over Hindu Invasion." The proposed ten-acre retreat near Lake Grove station "would include a structure for housing the Swami, as the priests of the [Vendenta] society are known, and cottages for students." Reportedly, a group of wealthy women in Los Angeles was backing the venture.

Lake Grove Civic Club members vehemently protested the plan. LeGrand M. Baldwin, husband of Lola Baldwin, the first municipal policewoman in

the United States, headed the committee formed to lobby the Ladd Estate Company to stop the sale. He also circulated a petition to prevent such an organization from coming into the community. In the end, the opposition won, and Lake Grove residents were spared the potential "invasion."

IT GETS MY GOAT

Municipal building codes had yet to be adopted at the time that Atchinson & Allen, the first marketing agents for the Oregon Iron & Steel Company, began to sell Oswego real estate in 1912. Successive twenty-five-year deed restrictions were imposed to maintain certain standards for the districts. The 1913 deed for a parcel in Lake View Villas states, "Premises not to be used for flats, apartments, stores, livery stables, dance halls or business or manufacturing purposes, and no intoxicating liquors to be sold or disposed of in any place of public resort." Rentals were probably excluded in response to the makeshift tent cottage rentals that had sprung up on the lakeshore.

Later deeds in effect banned goats because only dogs, cats or the usual household pets were allowed. Unfortunately, deed restrictions were also used for the purpose of racial discrimination. Certain non-whites were allowed as servants but not as residents. From 1926 on, the Ladd Estate Company, the second marketing agent for the Oregon Iron & Steel Company's real estate, touted their "Live where you play" slogan at every opportunity, but clearly not everyone was allowed to live where he or she worked.

THE GAS HOUSE

The "Gas House" isn't as ominous as it sounds. It was one of at least five model homes built in Oswego in the 1920s and 1930s. In 1939, it was reported that a duplicate of the prize-winning home in the American Gas Association and *Architectural Forum* magazine national contest would be built in Oswego. The Portland firm Johnson, Wallwork & Dukehart designed the home, sited on the corner of Iron Mountain and Country Club Roads. Romaine D. Ware, the former garden editor for *Ladies' Home Journal*, was selected as the landscape architect. A 1939 newspaper article reported, "Oswego people, and for that matter, the people of the entire Northwest are fortunate in having such a structure as this duplicate of the 'Gas House'

constructed here as all we ever see or know of these prize homes is a picture in some big Eastern magazine."

Architect Cameron Clark designed the "Life House" for *Life* magazine's home-building program. It opened on May 26, 1940, on Avenue A in the Lake Bay homes subdivision of the Lake Oswego Country Club district. Over four thousand visitors toured the house that was "presented as a modern dwelling ready to move into."

Richard Sundeleaf designed the Ladd Estate Company model home next door to its real estate sales office. When it opened on July 10, 1937, the public witnessed such innovations as automatic garage doors, rolling concealed window screens, an electric dishwasher and a power-driven garbage disposal. Modern conveniences packaged in architect-designed charm exemplified the residential vision for the entire district. Historic homes are typically named after the first owner. This house was originally purchased by Mrs. Edward G. Gordon, but the house is erroneously called the "White House" after Eugene L. White, an early, but not the first, owner. Sensitively enlarged, it still stands at 432 Country Club Road.

At 420 Tenth Street, across A Avenue from the Ladd Estate model house, stands the Johns-Manville model home, also designed by Richard Sundeleaf.

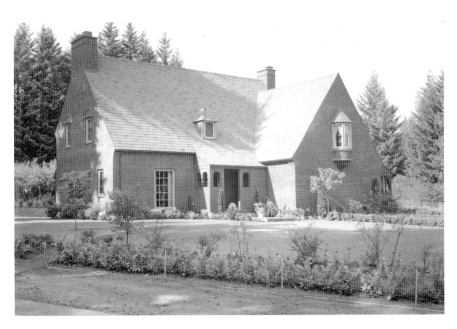

Architect Richard Sundeleaf designed the Johns-Manville model house built in 1936. *Photograph courtesy of Kasey Brooks Holwerda.*

It was built in 1936 for the Ladd Estate Company. Oswego, it was reported, "has been selected for the model house of triple-insulated construction as developed by the Johns-Manville engineers." The innovative products that were being showcased in this model house included asbestos.

Lake Oswego's Volcano

Mountain Park is the only Lake Oswego neighborhood built on an extinct volcano. Mount Sylvania is part of the Boring Lava Flow that occurred one to two million years ago. Today, Mountain Park is home to one-quarter of Lake Oswego's population. The forward-looking development was the brainchild of Carl Halvorson, who also developed Oregon's Black Butte Ranch and Little Whale Cove.

The Planned Unit Development began construction in the late 1960s, and it was dedicated in 1970. Governor Tom McCall was among the dignitaries at the dedication ceremony. Mountain Park was destined to become the largest homeowners association in the United States, and it remains one of the largest. The annexation of Mountain Park in 1969 eventually doubled Lake Oswego's tax base and population. A marketing slogan of that era was: "There's a new town in town." Portland, and its surrounding metropolitan areas, is one of the few places in the continental United States to have extinct volcanoes within the city's limits.

Buy Your Cow a Watering Hole

After Oswego's iron industry collapsed, the land began to be recognized for its real estate potential, but it wasn't easy to sell. The first development on the lake, Lake View Villas, dating from 1912, was on the northwest end of the lake. Lake Grove was considered a great place to picnic and camp but not to live year-round. The lack of good roads, the untamed shoreline and the dampness made view lots more desirable than those on the lake. Atchinson & Allen's real estate promotions offered a lake lot for $50 along with a purchase of an acre view lot. It was suggested that the lot on the lake could be used as a watering hole for the family cow. In contrast, by 2008, a lakefront estate was listed for $19.5 million.

Lakewood's Just Ducky

The "Duck Pond," as locals called it, was situated northeast of Sucker (now Oswego) Lake. During the iron era, Earl Hughes recalled, "there was an eighteen-inch steel [it was actually wooden] pipe coming from the main lake and going through the Duck Pond down to the smelter, with a gate to control the water." Hughes was referring to the second iron furnace located in what is now the Foothills area. As high-end residential development replaced iron as Oswego's largest industry, the Duck Pond didn't fit the vision of the town's largest developer, the Ladd Estate Company. The channel that had been used to pipe water was enlarged to flood the Duck Pond, and thus the more attractive and renamed Lakewood Bay was created in 1928. An ordinance was proposed to fine anyone referring to Lakewood Bay by its former name. A 1925 Ladd Estate Company brochure, perhaps prematurely, declared, "Of all Lake Oswego's districts Lakewood is the most accessible—the nearest—possessed of modern advantages. There is no more beautiful spot anywhere." A decade earlier Ward Cotton Smith said he had come "out to Oswego to look for the lake and we found a mud hole down here on State Street." Perhaps a rubber duck race on Lakewood Bay could be organized to pay homage to its humble origins.

The Duck Pond can be seen on the left in this photograph. In 1928, the Ladd Estate Company transformed this marshy area into Lakewood Bay. *Photograph courtesy of Lake Oswego Public Library.*

SELLING THE AMERICAN DREAM

The Home Builders Association of Metropolitan Portland opened the gates to the first street of custom homes in 1976. Four years later, the fifth annual Street of Dreams was held for the first time in Lake Oswego. Dick Edwards, the chairman in 1980, noted, "You, the viewing public, have a rare opportunity, not likely to be found in any other city in the world. This is the street where dreams begin, so enjoy the excitement of luxury living, but remember that these beautiful and expensive homes are not indicative of the basic housing market."

In the Tabaridge development, part of today's Holly Orchard neighborhood, homes with names such as the Tiara II, the Elegance and the South Castle were among the lineup. Prices ranged from $225,000 up to a $350,000 price tag for the "American Dream" house. These homes were fully furnished and landscaped to elicit an "I could just move in!" response from tour-goers. One special feature was the "Visible House." This home was envisioned as a living test laboratory for evaluating energy conservation measures. Rooms were purposefully left in various stages of construction to give viewers a behind-the-walls glimpse of various types of construction materials. Visitors could see foam and fiberglass wall insulation firsthand, a cutaway in the floor revealed ground vapor barriers and heated crawlspaces, the living room was equipped with a fuel-efficient wood stove and the garage contained a solar storage tank for heated water.

NO ALLIGATORS IN OUR EVERGLADES

St. Helen's Hall, the Oregon Episcopal girls' school founded in 1869, obtained a house at 16697 Maple Circle on Oswego Lake in 1930. By 1931, the house had been enlarged for use as a weekend retreat for the schoolgirls and named the Everglades. The *Oswego Review* reported, "St. Helen's Hall summer lake villa is situated on the east lagoon and has a beautiful setting."

The intent was to foster an appreciation for outdoor life. The lake was used for lessons in swimming, diving, lifesaving, boating and canoeing. Lighted tennis courts were also featured. Festivities such as picnics and graduation ceremonies were held at the Everglades. Sister Waldine Lucia Superior, it was reported, had her own motorboat from which she supervised swimming and water sports. Due to financial difficulties, the Everglades was sold in the 1950s.

A Tree Grows in Glenmorrie

Glenmorrie, dating back to 1908, was Oswego's earliest post-iron-era real estate development. In 1888, Parker Farnsworth Morey, along with Edward Lawson Eastham, founded the Willamette Falls Electric Company, a precursor of Portland General Electric (PGE). Morey later married Eastham's socially prominent and wealthy widow, Clara Caufield Eastham. With this money, Morey built a magnificent tree-filled estate on six hundred acres. In 1974, Herbert Yates recalled for an *In Their Own Words* interview:

> *Giant sequoias were planted, three of which survive, now grown to a considerable height.* Grandiflora magnolia, Cryptomeria, *walnut, birch, alder, ash, holly, maple, linden, dogwood, locusts, hawthorne, yews, cascara and laburnum were all well established. Plus the famous Empress trees brought from China, which still flourish.*

Trees and cuttings from around the world were delivered by steamship and offloaded at Morey's Landing, destined for the estate. Chinese laborers,

The Glenmorrie bus waits for passengers at the Oswego Depot. Chapin & Herlow inaugurated this bus service in 1911. *Photograph courtesy of Lake Oswego Public Library.*

formerly employed in the iron era as woodcutters to fell giant fir trees for charcoal production, ironically provided the heavy labor of building and planting the grounds with specimen trees from around the world.

After Morey's death, Ed Twining recalled in *In Their Own Words*, "That whole area in Glenmorrie was fast growing back to brush and grass. Old P.F. Morey spent a fortune there—an artificial lake, tennis courts, roads, great stone walls. When he died, it was more or less broken up and sold."

Clara sold the land to Morey's son Fred, and he, with partners Chapin & Herlow, created and promoted a real estate venture out of the estate to which Fred's father had been singularly devoted. To facilitate access and potential sales, a twelve-passenger jitney was provided to transport residents and prospective buyers between Glenmorrie and the Oswego Depot.

and here, much to his dismay and surprise—this was during prohibition in the early twenties—was a beautiful big whiskey still in full operation. Of course, to enjoy this, you should know the Twinings, because they would be the last people having a whiskey still in the top of their house. They were the most respectable that you could imagine, with sons going into West Point.

Another neighbor, Herbert Yates, recounted:

Tipped off as to the impending raid, the bootleggers fled, tossing some of the evidence into the ravine by the house as they left. Jim Welsh, plowing a nearby field, observed what was going on, and when things quieted down, retrieved the evidence. To confirm his suspicions, he sampled it, finding it a most excellent moonshine indeed. After stabling the team, Jim set out to share his discovery with a friend, Rube Confer, whom he found preparing to slaughter a pig back of his house on the riverbank. Jim prepared to help with the projected demise of the pig as soon as they had a couple of snorts of the evidence to nerve them to their task. So potent was the influence of the evidence that far into the night the three voices—Jim's, Rube's, and the pig's—could be heard raised in song.

GADZOOKS, IRON FROM THE SKY!

The Oregon Iron & Steel Company mined iron from the earth, but the metal also happened to be found on its lands in the form of a meteorite. Partly hidden by vegetation, the meteorite was uncovered in 1902 by a local farmer, Ellis Hughes. Most likely, the meteorite did not fall in Oregon but was carried here by the ice floe of the Missoula Floods fifteen to thirteen thousand years ago. The meteorite was later determined to weigh 31,107 pounds, but it was surreptitiously moved inch by inch from the discovery site across another farmer's land to Hughes's farm. After the Herculean effort, Hughes promptly put up a tent and began to charge a quarter for admission. The attraction caught the attention of an Oregon Iron & Steel Company official, and a lawsuit claiming it as company property was filed.

In the meantime, the farmer owning the land that had been traversed filed a countersuit. He had dynamited a hole in the ground and claimed that the meteorite had fallen on his property. On July 17, 1905, the Oregon Supreme Court ruled that the Willamette Meteorite, the largest found in the

Deanna Glanville is dwarfed by the base of a giant tree toppled in the 1962 Columbus Day Storm. *Photograph courtesy of Lake Oswego Public Library.*

home exploded when uprooted trees broke a gas line that ignited in a ball of flames. Falling trees smashed cars and homes. Roads were strewn with downed live power lines, telephone cables, trees and tree branches. In one freak occurrence at the Jane home at 242 Iron Mountain Boulevard, the wind lifted a vase and set it down on another table without spilling the water. Damage to the area was estimated at $1.5 million (about $10.6 million in 2012 dollars).

Moonshine Sonata

The "Scandal of Glenmorrie," as it became known, involved moonshine, a fire and a singing pig. In 1923, the Twining family rented their lavishly furnished country home in Glenmorrie to a man named Henry Habberman. Unbeknownst to the Twinings, Habberman was the leader, according to the *Oregonian*, of "one of the most notorious and elusive moonshine rings in the state." This may never have come to light if the gasoline burner under the huge still on the third floor had not exploded and set the house afire.

When the neighbors saw the smoke, Jane Erickson recalled in the oral history *In Their Own Words* that her husband rushed over to the house,

One of the players, Stanley G. Terry, a pinball operator, lived on West Point Road in the Lakewood neighborhood. Pinball, a game of chance, not skill, was considered a form of gambling. In an effort to combat the illegal gambling problem, Portland, like many other cities across the nation, banned pinball machines. Stan Terry's attorney, testing the constitutionality of the edict, appealed to the United States Supreme Court. Phil Stanford, in his book *Portland Confidential*, stated:

> *In 1967, Stan Terry, who, following the Supreme Court's ruling in favor of Portland's pinball ban, had been forced into other illegal activities, fractured his skull in a fall from a ladder while painting his home in Lake Oswego. Upon recovering, he became a frequent candidate for political office, running at various times, quite unsuccessfully, for mayor, Portland city commissioner* [regardless of the fact that he wasn't a resident of Portland], *county commissioner, and governor.*

According to a former neighbor, Stan Terry kept a flock of sheep on another parcel of land in the city. Since farm animals were not allowed within the city limits, Terry spray painted the flock and told officials that they were not sheep because such brightly colored sheep didn't exist.

THE WINDY CITY

Hurricane-force winds brought widespread destruction and one death to the Lake Oswego area. Now known as the Columbus Day Storm, it etched memories in the minds of a generation of Oregonians. High winds had been predicted but not the ferocious gales that struck about 5:00 p.m. on October 12, 1962. What began as Typhoon Freda became a non-tropical windstorm that swept through Oregon from south to north. To this day, it remains the strongest storm to hit the lower forty-eight states. Peak wind gusts at the coast reached 138 miles per hour before the wind instrument was damaged. A local newspaper reported that many large beautiful trees in Lake Oswego were toppled as though they were matchsticks. Adrianne Brockman recalled that on that day she was riding four-abreast in the Oswego Hunt arena when she noticed a huge uprooted tree rolling down the polo field as if it were a tumbleweed.

Mrs. Sarah J. Nordeen stood in her yard to witness the fury of the storm and was crushed by a falling tree; this was the only fatality caused by the storm in Lake Oswego. Two homes were ripped to shreds by the wind. One

9

IT CAN'T HAPPEN HERE
Criminals and Natural Disasters

DID YOU KNOW?

- After the city was incorporated in 1910, one pair of handcuffs was purchased from Portland's H.T. Hudson Arms Co. for five dollars. The powers that be must have anticipated apprehending one criminal at a time.
- In 1931, a letter to the editor of the *Oswego Review* extended an invitation to the thief who stole one sock from a clothesline to come and get the other sock.
- The *Oswego Review* reported in 1938 that five houses were robbed in a single day. Among the loot was one dollar stolen from the baby's bank at the home of Charlie and Bernie Didzun on A Avenue.

PINBALL WIZARD

Racketeering and political corruption were rampant in Portland in the 1950s. Teamster Union officials and local racketeers provided kickbacks to the Multnomah County district attorney, William Langley, and other law enforcement officials so they could operate the city's booming vice industry without interference. The underbelly of corrupt Portland drew national attention, and Robert F. Kennedy, chief counsel to the 1957–59 Senate Labor Rackets Committee, was pursuing teamster leader Jimmy Hoffa, while Kennedy was also involved in Portland's federal cleanup.

Although the Willamette Meteorite did not fall in Oregon, it was found on property owned by Oswego's Oregon Iron & Steel Company. *Photograph courtesy of Lake Oswego Public Library.*

United States, was the property of the Oregon Iron & Steel Company. It was displayed at the 1905 Lewis and Clark Centennial Exposition in Portland and subsequently purchased by Mrs. William E. Dodge II of New York City for $26,000, an amount that would be equal to $656,000 in 2012 dollars. Mrs. Dodge, heiress of the Phelps, Dodge and Company mining operations, donated it in 1906 to the American Museum of Natural History, where it is still on display.

Many Flu the Coop

The Spanish flu epidemic of 1918, officially known as the Influenza Pandemic of 1918 and 1919, lasted just over a year but lived forever in the minds of those who survived. This epidemic took the lives of twenty to forty million people worldwide. The dead exceeded the number of causalities in World War I, and casualties were greater than the number of deaths caused by the bubonic plague during the Middle Ages. Stories were told of people on their way to work being stricken with the flu and dying within hours.

Oswego schoolchildren who coughed or sneezed were sent home at once. Burials of flu victims in the Oswego cemetery spiked. Marian Weidman recalled in *In Their Own Words*, "That's when they had the flu epidemic, and people were dying like flies and the hospitals were filled to over capacity." Mary Strachan also recalled, "Their [the Pettingers'] home was a gathering place for soldiers during the First World War. And, in the flu epidemic of 1918, Mrs. Pettinger secured Dr. Rossiter, the town's only doctor, to give flu shots to us all."

A TEN-DOLLAR REWARD

On the afternoon of August 13, 1903, Wilda Parker of Oswego deserted her home and four children and, as it later became known, fled with a man. Her husband claimed that she quarreled with her eldest daughter, Lona,

A Reward of $10

Sports as Pearl Jackson or Moss

Will be paid for the location of Wilda Parker and John F. Grant. Mrs. Parker deserted her home and four children in Oswego, Ore., Aug. 13th, 1903. She first went to McMurry, Wash., then to Montacello, Cal., where she passed as Clara Thompson and Alta Moss. She is 36 years old, is 5 feet 6 inches in height, weight 155, eyes very large and blue, hair dark, complexion fair, front teeth gold filled.

John F. Grant her accomplice is an ex-convict as Frank Stice, alias John F. Thompson or Chas. Moss, is 38 years old, 5 feet 9 inches tall, weight 150, has peculiar round head and face, with scoup-shaped lower lip, a scar on his forehead above eyebrow, is french decent.

News Papers please copy.

Address

I. B. SMALL,

Oswego, Oregon.

The ten-dollar reward poster for the elusive Mary A. Small, also known as Wilda Parker. *Image courtesy of the Lake Oswego Preservation Society.*

and stormed out of the house declaring that she would never return. The sixteen-year-old Lona later explained in a letter to the *Oregonian* that her father was cruel and abusive, and this prompted her mother's exodus.

A wanted poster offering a ten-dollar reward described Mrs. Parker, whose real name was Mary A. Small: "She is 36 years old, is 5 feet 6 inches in height, weight 155, eyes very large and blue, hair dark, complexion fair, front teeth gold filled." A handwritten note on the poster indicated her other aliases as "Pearl Jackson or Moss."

Mrs. Parker's partner, Frank Stice, who went by the name of John F. Grant, reportedly was an ex-convict

who also used the aliases John F. Thompson or Charles Moss. He was described on the poster as "38 years old, 5 feet 9 inches tall, weight 150 has peculiar round head and face, with scoup-shaped [*sic*] lower lip, a scar on his forehead above eyebrow, is French decent [*sic*]."

I.B. Small claimed that his wife had dementia and might have been suicidal. After a year-long hunt that included dredging the river for her body and traveling as far afield as New Mexico, Mr. Small concluded that his wife had deserted him, and he continued the chase for some time with revenge in his heart. Lona, in the meantime, turned the youngest child, Emma, over to the Boys and Girls' Aid Society because she was unable to care for her three siblings in her father's absence. In 1904, Mr. Small gave up and returned to Oswego to commence proceedings for a legal separation.

AHOY, MATEY!

"Pirates! Yes, sir, they are on Lakewood Bay—spied by our sharp-eyed Chief of Police L.W. Shriner, and as is the way of all highway men of the deep they came to a dreadful end." The *Oswego Review* reported this event in September 1938. As the article continues, it is revealed that the pirates ranged in age from eight to eleven. They plundered two cabanas on the lake while the tenants slept. Their spoils included a valuable ring, a fountain pen, an alarm clock and a Bible. They had set sail on their pirate ship with the booty aboard when the chief of police apprehended the foursome. The article concludes, "It's a lesson the boys will never forget—thanks to the fine work of our chief of police and to the tender care the parents gave the boys via the woodshed."

A GRAVE OFFENSE

In life and in death, William Sargent Ladd was a major figure in both Oswego's and Portland's histories. Ladd opened the Ladd and Tilton Bank, Oregon's first bank, in 1859; he served as Portland's mayor twice; he was founder of Oswego's iron industry; and Ladd Street in Old Town is named for him. In 1897, four years after Ladd's death, Daniel Magone, the son of well-respected Oregon pioneer Major Joseph Magone and a son-in-law of Waters Carman, was sentenced for robbing William S. Ladd's grave in River View Cemetery and holding his remains for ransom. The case of illegal

The Magone sisters are pictured from left to right: Lulu, Francette and Marie. *Photograph courtesy of Lake Oswego Public Library.*

disinterment went to the Oregon Supreme Court, and Julius Caesar Moreland, for whom East and West Moreland are named, was his legal representative. Daniel Magone was found guilty and served two years in the penitentiary. Ladd's body was reinterred and cemented into the ground. A guard stood duty until the cement hardened.

The impetus for this gruesome act may never be known. Magone's daughter, Francette, drowned in 1893 at seven years of age in the canal that connects the lake with the Tualatin River, property owned by Ladd. Francette's tutor also drowned attempting to save her. Francette's death may have been a factor in Magone's deranged behavior.

A GATHERING OF THE KLAN

In the early 1920s, the Ku Klux Klan was strong in Oregon. One goal, in concert with the Oregon Scottish Rite Masons, was to make public education mandatory, thereby denying access to private education. The Sisters of the Holy Names have been based in Oregon since 1859 and in Oswego since 1908. The year they arrived in Oswego, they established the St. Mary's Home for Girls to house and educate orphaned and abandoned girls. The sisters were dedicated to their mission of education.

As Klansmen increased their opposition to private education, the sisters not only boycotted businesses that supported the Ku Klux Klan but also challenged the KKK in the courts. The now famous case is known as *Pierce v. Society of Sisters*. Walter M. Pierce, a state senator, was elected governor of Oregon in 1922 with the support of the Ku Klux Klan. In 1925, the United States Supreme Court handed down its unanimous decision. The court ruled in favor of the sisters: states may compel attendance at some

schools, but the parents have a constitutional right to choose between public and private schools. This landmark case has been cited as a precedent in over one hundred United States Supreme Court cases.

Open the Floodgates

Jane Erickson, an amateur geologist and playwright who made her home in the Glenmorrie neighborhood, recalled:

> *Following a well-defined line along the lake's upper bluffs, as far west as Wilsonville, can be traced another event as momentous as any written in Oregon's geologic past: the Missoula Floods. At the end of the last ice age, in what is now the state of Montana, a huge ice dam gave way. Behind it were backed up hundreds of cubic miles of water and this immense pent-up volume swept down the Columbia Gorge to a height of a thousand feet, eating away mountains, uprooting forests, and bringing havoc and destruction to all in its path.*

The floodwaters were still several hundred feet deep as they swept through the lake area, then possibly occupied by the Tualatin River. After the floodwaters subsided, they left behind a body of water once called Tualatin Lake, or Sucker Lake, and known since 1913 as Oswego Lake.

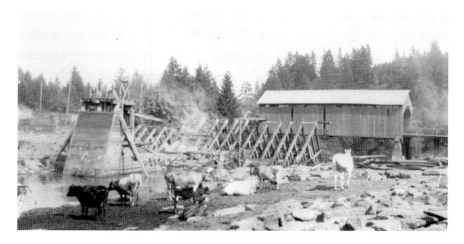

Cows and a horse observing the demolition of the wooden dam on Oswego Lake in 1921 in preparation for the construction of the concrete dam. *Photograph courtesy of Lake Oswego Corporation.*

Over time, a succession of wooden dams, followed by a cement dam built in 1921, have increased its size, but the lake was definitely made by forces beyond human control.

A DIRTY BUSINESS

In 1937, the *Oswego Review* reported that Clifford (Happy) Johnson was arrested and charged with removing dirt from a city street without permission. Johnson asked for and was granted a jury trial. The attorney for the city, O.C. Roehr, "opened the case with the reading of Ordinance 270, which states that: No person or persons shall dig or remove any dirt or other material from the streets of Oswego without a written permit from the office of the City Recorder."

Mayor William S. Ewing testified that Johnson "had removed dirt from low places in the street [Tenth Street] contrary to the original agreement" and that he had even left a hole. Johnson and others testified "that at no time had more than fourteen inches of dirt been removed." In the end, "the jury found the defendant not guilty of the charge but recommended that he refrain from removing any further dirt or other material from any city street without first obtaining permission from the city recorder."

THERE'S A LADY LIVING IN A DRYER

Feared and well studied, polio gripped the nation in the 1940s and 1950s. Worries caused by this frighteningly random disease were put to rest thanks to Jonas Salk's development of the polio vaccine in 1955. Today, there are few instances of the infectious poliomyelitis disease in developed nations. According to Joan Fewless Quigley, it was quite a different story seventy years ago. In a reminiscence entitled *Ripples on the Lake*, Quigley says, "In 1943 through 1946 the polio epidemic hit. No more gathering at the park to swim and no more going to the crowded movie theater in Oswego. Needless to say, our social lives were definitely curtailed."

Although the Oregon State Board of Health records on infectious diseases for this period do not indicate as high an incidence of polio as recollected, Quigley continues:

> *As an adult, I lived in the town of Oswego, on a street where there were five houses with iron lungs in the front windows. There were generators on the*

The first grade class at Lake Grove School in 1947 during the era of the polio epidemic. *Photograph courtesy of Lake Oswego Public Library.*

front lawns, and if the electricity went out in the area, the volunteer firemen would arrive at assigned locations, and pump the generators by hand until electricity was restored. My child, on her way home from kindergarten, came in and told me, "There's a lady up the street who lives in a dryer!"

MOVING HEAVEN AND EARTH

On Sunday, May 18, 1980, Mount St. Helens, a volcano in southwestern Washington, literally blew its top—or perhaps that should be blew "her" top. In Native American legend, the brothers Wy'east and Klickitat both fell in love with a beautiful maiden named Loowit. The brothers fought over her and wreaked so much havoc that the gods punished the trio by turning them into Mount Hood, Mount Adams and Mount St. Helens.

When the volcano erupted, many townspeople went to the top of Mountain Park or Skylands to watch the eruption. Ash blanketed Lake Oswego and, of course, made national news. The *Pittsburgh Press* reported, "The southern border of the ash fallout was placed at Lake Oswego, Ore.,

70 miles southwest of the mountain. It extended another 55 miles west of Lake Oswego to Tillamook on the Oregon coast then to Astoria, Ore., 65 miles north of Tillamook."

Jack Walsdorf, vice-president of sales at Blackwell North America in Lake Oswego, turned the event into a marketing opportunity for the British-based bookseller. Bags of ash were distributed at the 1980 American Library Association summer conference and mailed to Blackwell's customers with a promotional sheet including the message: "We move the earth for you."

10

LET ME ENTERTAIN YOU

Events and Recreation

- Oswego entered a float in Portland's Rose Parade in 1959 to honor Oregon's centennial of statehood. It featured a flower-bedecked iron furnace and the words "Lake Oswego: Pittsburg [*sic*] of the West." Someone should have consulted a dictionary.
- Some of the terrain on the Iron Mountain section of the original Oswego Lake Country Club golf course was so steep that a Pierce Arrow open touring car rigged to a cable system transported club members to the twelfth tee.
- Around the turn of the twentieth century, seven Oswego jokesters posed for a photo, each holding a beer in one hand and a plucked chicken in the other. One could definitely accuse them of "fowl" play!

WATER-SKIING ON PIE TINS

Among the first to water-ski on Oswego Lake was a foursome composed of Willa Worthington, Ray Morris, Diane Spencer and Don Smith. After work, they skied off the dock of Wallace Worthington's Marine Sales and Service, better known as Wally's Marina, between State Street and Lakewood Bay. Wally taught his daughter, Willa, to water-ski when she was fourteen. At age seventeen, she became the National Women's Water-Ski Champion. She went on to win other national and international awards that made Oswego famous for the sport. Willa organized the Lake Oswego Water-Ski Club in 1947.

Lake Oswego water-skiers who became stars of Florida's Cypress Gardens. *From the left*: Ray Morris, Willa Worthington, Diane Spencer and Don Smith. *Photograph courtesy of Lake Oswego Public Library.*

In the early 1930s, aquaplaning on Oswego Lake had been a precursor to water-skiing. This sport used a wide board towed by motorboat. The term "water-ski" was introduced to the English language as a noun in 1931 and as a verb in 1953. In the sport's early days, experiments were tried with mixed results. Ray Morris, among others, successfully nailed tennis shoes to boards. Don Smith tried to ski on pie tins, but this failed because the tins buckled. After the marina burned to the ground, the four became stars of the aqua shows at Florida's Cypress Gardens.

GOING TO BAT FOR OSWEGO

In 1910, President William Howard Taft began a baseball tradition by throwing the first ball at the season's opening game. During the next decade, Babe Ruth and Jim Thorpe were internationally famous, and Oswego had its own locally renowned baseball teams. Early photographs of Oswego teams date back to 1905. Baseball players included well-known Oswego family names such as Davidson, Didzun, Worthington, Shipley, and Blanken. Fraternal organizations also organized baseball teams. In a 1917

An Oswego baseball team suited up for a game about 1915. The little girl in the photograph is Retha Kaiser. *Photograph courtesy of Lake Oswego Public Library.*

Oswego Times article on the Oswego Red Men team, it was reported that "Harry Headrick ran and caught a seemingly impossible fly ball." Many games were played at a baseball diamond located where the Oswego Village Center, anchored by Albertson's, stands on State Street today.

MERCHANTS OF VENICE

Both of the original Oregon Iron & Steel Company marketing agents who shaped the city's early residential landscape deliberately linked Oswego with Venice. Although Oswego's Venetian elements consisted of a canal and occasional flooding, Atchinson & Allen named the first two lakeshore developments Lake View Villas and Oswego Lake Villas. Later, the Ladd Estate Company built cabanas on Lakewood Bay. It was perhaps inevitable that a gondola was added to the Italianate theme.

In 1927, the *Oregonian* announced, "Gondola shipped to City—Real Venetian craft to be used on Oswego Lake." Shipping manager R.W. Cook told the *Oregonian*, "I've had to do with a varied list of freight, including items curious and costly, but delivering a real honest-to-goodness Venetian gondola is one I can log as different."

The Venetian gondola cruises Oswego Lake. The passengers may be girls from the St. Helen's Hall retreat on the lake called the Everglades. *Photograph courtesy of Lake Oswego Public Library.*

The gondola came to Oswego Lake from Venice by way of the Philadelphia Sesquicentennial Exposition. A gondolier wasn't necessary except as a helmsman because the craft was propelled by two portable electric motors. The gondola's days of glory came to an end when it eventually sank in the lake.

CHASING PAPER

A "paper chase" sounds more like bureaucracy than entertainment, but Lake Oswego Hunt members once enjoyed this amusement. Paper chases are an equestrian game in which one team starts off on a long run, scattering small pieces of paper—in other words, the scent. The other team follows the paper trail in an effort to catch the first team's members before they reach a certain point. This game originated in the mid-1800s. "Fox" hunts were also held at the Lake Oswego Hunt. The "fox" was a bag of scent dragged along the ground for the hounds to follow.

The origins of the Lake Oswego Hunt date back to 1928. The Ladd Estate Company, at that time the marketing agent for Oregon Iron & Steel, used 1,400 sticks of dynamite to clear the way for construction of a polo field by persuading Springbrook Creek to change its course. After this dynamite beginning, the Great Depression of 1929 gripped the nation. In 1936, when the economy began to recover, the Oswego Hunt complex was added to the

116

site at the base of Iron Mountain. This included a track, clubhouse, barns and an arena on nineteen acres of land. Bridle trails also crisscrossed the face of Iron Mountain, some following the path of the old mine rail bed. All of these amenities created by the Ladd Estate Company were designed to appeal to the upscale homebuyers, who were attracted to Oswego as an ideal place to, as the marketing slogan touted, "Live where you play."

Satellites Launched in Lake Oswego

"Super Satellites" were a type of monohull sailboat originally favored by the Lake Oswego Sailing Club founders. Sailboat owners who lived on Oswego Lake, including Tony Dresden and Bob Young, formed this club in the early 1960s. An annual two-day event, the Lakewood Bay Regatta, was held each August, along with other races throughout the year. Whether there were gale-force winds or balmy breezes, the races proceeded. Intrepid sailors were sometimes capsized by wind and had to withdraw from the race. On at least one occasion, women protested the male-dominated races and organized a women-only race. Instead of a flag, a red-colored woman's undergarment was flown at the end of the race as a sign of protest. In 1974, there were seventy-eight races, as well as social gatherings of the club. The club roster in 1980 listed fifty-one sailors and nineteen types of boats. Later in the 1980s, the interest in sailing on the lake waned, and the club disbanded. There are photographs of sailboats on the lake dating back to 1900. Perhaps with the current focus on sustainability, what's old will be new again, and wind-powered sailboats will dot the lake once again.

Past Tents

Tents date back to the earliest nomads and are one of the first forms of shelter ever constructed. Rustic tent cottages, built with wooden sides and canvas roofs, once dotted the eastern end of the lake. According to the City of Lake Oswego's 1989 Cultural Resources Inventory:

> *David Nelson leased the lake shore property from the Oregon Iron & Steel Company for $1 per boat per month. By the time Nelson died in 1923, he had a fleet of 50 rowboats, which he rented out from a concession on the lake. A four-person rowboat cost $1 to rent, while an eight-person boat cost*

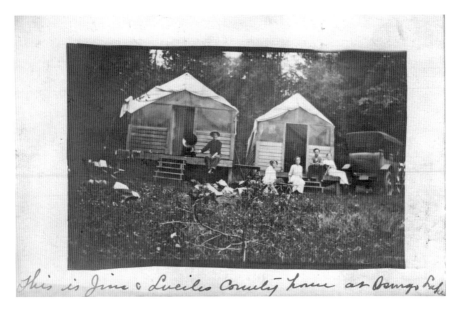

A 1915 postcard of two tent cottages with the handwritten message: "This is Jim & Lucile's country home at Oswego Lake." *Photograph courtesy of the Lake Oswego Preservation Society.*

> *$2.50. Nelson also owned several "tent cottages" and a summer ice cream stand. The cottages, four-foot wooden sides with tent roofs, sat nestled in a pine grove a short distance from the rowboat rental area. A few, heated with wood stoves, were occupied all winter.*

The Nelson family's business, started in 1904, was the first commercial promotion of the lake for recreational purposes. During the iron era, Sucker Lake (now Oswego Lake) was stump-filled and unattractive to all but curious children.

GOING OVERBOARD

Gunpowder is typically used to blow up boats, not power them. In 1929, an experimental rocket-powered boat was tested on the waters of Oswego Lake. The craft was referred to as a "boom, boom boat," but its inventor, Ray Lindsay, officially named it the *Flying Lena*. The first part of the maiden voyage was reported by the *Oregonian*: "The fuses attached to the three tubes of powder were lighted. The rockets exploded with a

mighty detonation. *Flying Lena* quivered, then suddenly shot forward." The article continues:

> *That much Mr. Lindsay related seriously. Then laughingly added more vivid recollections of the trip. Instead of all the powder exploding at once some continued to sputter and burn in the stern of* Flying Lena, *he said, while the boat rocked recklessly forward. Mr. Lindsay gazed at the threatening projectiles, looked at the inviting waters of Lake Oswego* [sic] *and jumped overboard!*

THE WHITE HOUSE, A DEN OF INIQUITY

Today's Macadam Avenue was once known as White House Road for an establishment that was situated about halfway between Portland and Oswego. In 1886, Hermon Camp Leonard, the fourth wealthiest man in Portland and a principal player in Oswego's iron industry, bought the business and renamed it the Riverside Hotel. The popularity of the White House, as it continued to be called, was based on horse racing, trap shooting, gambling, drinking and other comforts and distractions.

In a 1939 Works Progress Administration interview, Rush Mendenhall recalled:

> *All the gay folks in town went out to the White House where no questions was asked and most anything could be had. I was under age, I remember, and couldn't get anything in town, but nobody questioned me out there. Leonard kept up the Macadam Road through levying a toll. It began at*

The notorious White House pictured with the adjacent racetrack. *Photograph courtesy of Lake Oswego Public Library.*

about the foot of Hall Street, if I remember correctly, where the tollgate was. About half way out there was a place called the Red House, but that was later and not high-toned like the White House.

According to the *Oregonian*'s front-page story of June 28, 1904, the day after the White House burned to the ground

a motley throng of railroad laborers ran from their camp and, when they learned that it was not a church [that was burning] *risked their lives manfully in carrying out cases of beer, champagne and other such beverages. In about 20 minutes the whole railroad camp was drunk, but those that could navigate continued to work manfully until most of the stock was safely outside the burning building and inside themselves.*

In the Swim

Lake View Park at the west end of Oswego Lake was built in 1913 as an outdoor sales "office" for prospective homebuyers in the Lake View Villas residential district, the first development on the lake. Atchinson & Allen, the exclusive marketing agents for the Oregon Iron & Steel Company at that time, met passengers at the Lake Grove Red Electric station and took them aboard the Lotus, a small launch with a jaunty striped awning, for a scenic tour of lakeside lots.

The Ladd Estate Company, the second marketing firm hired by the Oregon Iron & Steel Company, built a sales office on nearby Graef Circle, so the park was offered to the Lake Grove community. After being turned down twice, Paul C. Murphy, as head of the Lake Estate Company, donated the park to the school board, which accepted it. It is now Lake Grove Swim Park, and deed restrictions reserve the use of the park for resident schoolchildren.

In the Lakewood neighborhood, the Ladd Estate Company, under Paul C. Murphy's direction, gifted land for the Oswego Municipal Park on Ridgeway Road. Lakewood homeowners fought it on the basis that it would hurt property values. The heated issue of public access was resolved by a vote. The park was completed in 1936 and dedicated with the mayor and Lassie, the assistant lifeguard dog, in attendance.

Spellbound

The first printed reference to a spelling bee was in 1825. The impetus for these contests was the publication of Noah Webster's *American Spelling Book*, a basic textbook used in elementary schools of nineteenth-century America. In 1938, Sara B. Wrenn, employed by the Works Progress Administration, interviewed Mr. Charles Towt Dickinson, the husband of Florence Smith Dickinson, founder of Dickinson's Jams and Jellies. Dickinson shared a memory of the Oswego area circa 1884:

> *Our community center was what was known as the Springbrook Schoolhouse* [this was the first Springbrook School building]. *In the spelling bees two of the outstanding spellers or scholars would choose up sides and the district teacher would select and give out the words. Just one chance was given and when the speller missed he or she would have to sit down. The last one up was the winner. "Assafoetida" was a favorite word to down them with.* [Assafoetida is a medicinal gum resin.]

Tiger by the Tail

In 1964, the circus came to town—the robot circus, that is. It was a sixty-three-piece animated circus "all precision made and shipped direct from W. Germany." The meatpacker Armour and Company sponsored the event,

Fred and David Shubert braving the life-sized robot tiger at the Big "C" market. *Photograph courtesy of Lake Oswego Public Library.*

and the circus made the rounds of Portland-area grocery stores from 1963 to 1965. In celebration of its sixth anniversary, the Big "C" market, near where the Albertson's market on State Street is currently located, was the local host. Newspaper ads played up the circus theme with graphics of clowns and a big top. Displayed throughout the store were "63 performers from West Germany," everything from a "fiery-eyed tiger to the trained seals in action." It was billed as "a real treat for the whole family."

FLAT BOOTS WALK ON WATER

In 1937, "flatbooting" was introduced in Oregon on Oswego Lake. A Bavarian man, who went only by his last name, "Klepper," made the modern flatboot a commercial success in the early 1900s. Flatbooting sounds more like walking than sailing, but the German term "falt boot" means folding boat. A little may have been lost in translation when the term for this collapsible kayak crossed the Atlantic. According to an article in the *Oregonian*, "It is the poor man's yacht, the rich man's toy and the sportsman's constant companion when once he makes its acquaintance."

The boats featured a seasoned ash frame covered with a rubberized canvas, and the fittings were brass. It could be assembled in about fifteen minutes, but the record time was four and a half minutes. The article continues: "The flatboot is so constructed that it can go anywhere that there is an inch of water. It can almost float on the dew that falls on the land." It was also designed so the center of gravity was below the waterline, and this made it "practically non-capsizable." Flatbooters could bid the tippy canoe farewell. Optional attachments converted the flatboot into a sailboat or an outboard motorboat. Although the name "flatboot" is no longer in use, Klepper collapsible kayaks are still sold today.

PONY EXPRESS RIDES AGAIN

The Great Depression was the impetus for the Multnomah Hunt Club's move from Oswego to Portland. In its stead, local riders organized the Oswego Hunt in 1933, and in 1939 the organization of members and other recruitments formed the Clackamas County Sheriff's Posse. Ralph Giesy recalled, "In 1941…the posse put on, in connection with Timberline Lodge, the first of two Pony Express races. The race, starting on the polo grounds

A postal commemorative envelope carried on the Pony Express ride from Oswego to Timberline Lodge in 1941. *Image courtesy of the Lake Oswego Preservation Society.*

at the Oswego Hunt (June 29 at 8:30 a.m.) went by the post office to pick up mail." The route over the old Oregon Trail was seventy-one miles long. The winning team delivered its mailbag in five hours, forty-four minutes and twenty-one and two-fifths seconds.

Giesy also recalled how a celebratory banquet was held at Timberline Lodge; the winner was presented with a beautiful trophy, and the event was covered by *Life* magazine. Giesy recounted, "The ride was so successful—not a horse exhausted or a rider injured—that it was repeated in 1942 on June 28." There was one last Pony Express ride in 1959 to celebrate the centennial of Oregon's statehood. By that time, the posse had moved its headquarters from Oswego, and the starting point was the Pioneer post office building in Portland.

Having a Cow
Animal Tales

Did you know?

- In 1936, Dutch, the faithful dog of Betty Ann Fryer, graduated from Oswego grade school. Robert Ripley reportedly hoped to use this story on his radio program *Believe It or Not*.
- During the winter of 1937, an *Oswego Review* article mentioned that hungry swans on the lake were particularly fond of eating boiled potatoes.
- Miss Oregon Lita Schiel water-skied with her dog, Yogi, on Oswego Lake in 1966.

Illiterate Cows

On March 19, 1914, the Oswego Woman Club's committee chair, Mary C. Smith, petitioned the mayor and city councilors for permission to install a public drinking fountain on the southwest corner of A Avenue and Front Street (now State Street). In 1966, Kenneth L. Davidson recalled that Oswego's first mayor, Jerome Thomas, "knew all of the cows by name." His recollection continues, "I remember well the cows using the old drinking fountain at First and A, where a fellow had to take his turn with the cows to get a drink." The situation was remedied by posting a board that read, "No cows allowed beyond this sign." Needless to say, cows ignored the sign and continued to quench their thirst in the fountain.

OSWEGO'S BEAR POPULATION

In 1902, United States president Theodore "Teddy" Roosevelt spared the life of a trapped bear, and this incident inspired the creation of one of the most popular and timeless toys: the teddy bear. Roosevelt, upon being asked permission to use his name in conjunction with the toy, reportedly replied, "I don't think my name is worth much in the toy bear business, but you are welcome to use it."

By 1906, the teddy bear craze in the United States was in full swing, and it spread to Oswego. American manufacturers created all manner of bears, from ones on roller skates to those with electric eyes. German manufacturers provided stiff competition. In 1907, the German toy company Steiff, which had adopted the name for its stuffed bruin, sold 974,000 teddy bears. Society women and children alike carried him to the theater, on walks and to school. Millions of teddy bears are still sold each year.

Oswego's Ava Bickner and Constance Koehler with their teddy bear companions about 1918. *Photograph courtesy of Lake Oswego Public Library.*

DOG AND HORSE RACING, OSWEGO STYLE

In 1933, riders entered a race across the lake on horseback as part of the Lake Oswego Water Carnival. An article in the *Los Angeles Times* called this event an "equine regatta." Herbert Kruse, of the Kruse farming family, entered an unlikely pick: his plow horse, Old Dobbins. Herbert Kruse recalled:

> *I knew I had tough competition in this race with a big draft horse that weighed sixteen hundred pounds against a light race horse. I didn't feed my horse the day before because I knew that feeding a horse and filling him up with hay and grain would put pressure on his lungs. Being able to get his breath all the way across was a very important thing. Nothing takes your breath faster than swimming. And another thing is, I lined up a tree across the opposite side of the lake that would go in a straight line instead of in a curve.*

The other strategy he used was to encourage his horse verbally instead of whipping him. Herbert Kruse and his horse won the race by approximately fifty feet.

On September 3, 1935, the *Oregonian* reported on a three-day Oswego event, the Aqua Show. Herbert Kruse won the horse race again, with several thousand spectators on their feet in the grandstand to witness the close finish. Herbert Kruse won by only half a length.

A dog race was also staged as part of the Aqua Show festivities. Dogs in the race were taken to the center of the lake and dropped overboard. Their owners stood on the shore and called to their dogs to encourage them in the race to shore. Idella Moore of Oswego and her dog, Spider, were triumphant. It is assumed that Spider used the dog paddle to swim to victory.

HUMAN FISHES

In 1917, the Lake Grove Angler's Club organized a tournament that included two "human fishes" in addition to the regular program of casting contests. According to the *Oregonian*, Earl Laramore and Sidney Vincent impersonated the fish. Two of the best anglers in Portland were challenged by attempting to "land" the fish.

The contest involved a fishing line firmly attached to football-like headgear worn by the "fish." The object was for the angler to play and tire the fish to

prevent the two temporary "denizens of the deep" from reaching a float two hundred feet off shore. Unfortunately, the outcome of this unusual contest was not reported; it was one fish story that got away.

ANIMAL HOUSE

Nestled among the houses in today's Country Club–North Shore neighborhood is a home built specifically for monkeys. The original owners of this 1929 house, Noel and Lola Dew, kept pet monkeys and had a small stone cottage built to house them. A stuffed Curious George is the only monkey currently in residence.

And today's Blue Heron neighborhood includes a "Pig House." Real pigs never actually resided in this brick house. Christian and Dorothy Kisky modeled their bathhouse after the 1932 Walt Disney cartoon *The Three Little Pigs*. Walt Disney provided costumes for a party in the 1930s, and he sent original cartoon sketches that were hung on the bathhouse walls.

A party at the Kisky's "Pig House," with guests dressed up as a wolf and one of the Three Little Pigs. Mr. Walt Disney provided the costumes. *Photograph courtesy of Lake Oswego Public Library.*

ADAM AND EVE LIVED IN OSWEGO

Adam and Eve were a pair of swans that once lived on Oswego Lake. They were not truly wild swans, as the name "Waluga," which is often associated with Oswego Lake, is said to imply. West Bay resident and retired Portland policewoman Lola Baldwin had been allowed to relocate Adam and Eve from Portland's Eastmoreland neighborhood to the lake in the autumn of 1927.

Swans usually mate for life, so Adam's paradise was lost when Eve swallowed a fishhook and died. After Eve's "swan song," Adam became ill tempered and began attacking anglers. Paradise was eventually regained when "Eve, the Second," as she was dubbed by Oswego Lake residents, appeared on the scene. In 1939, the *Oregonian* reported, "A romance that has all of the Lake Oswego district agog, not excepting even the more polite residential sections, is flourishing in Lily Pond."

GLENMORRIE'S FOR THE BIRDS

The abundant bird life in the Glenmorrie area inspired Frances Staver Twining to write and publish *Bird-Watching in the West* in 1931. One of her stepsons, Clarence, recalled that the birds would "come right up and sit on the windowsill like pets." In her preface, Twining states, "I have tried to put into words something of the intrinsic charm of the birds themselves, and to show how simple and how wonderful a thing it is for an everyday person like myself to win and enjoy the companionship of the birds who live just outside our windows. The doing has been a privilege." She also includes a quote from William Rogers Lord: "A bird in the heart is worth more than a hundred in the note-book."

DOGGONE DENTIST

The *Oswego Review* published a story in 1939 on Dr. J.D. Finlay that reported he's "taking a lively interest in all public and civic activities, singing anything from solos, in quartete [*sic*] and in choruses to 'Who Will Sew a Button on My Mother-in-Law's Lip,' serving on committees for church, lodge, and civic, attending all functions from juvenile birthday parties to centennial celebrations." In a word, he made himself an "all-round good citizen."

The story goes on to say that one of Dr. Finlay's hobbies was raising dachshunds. When a mishap resulted in the two broken front legs of one of his elongated dogs, the inventive dentist put wheels on the cast, and the dog was able to wheelbarrow about under its own locomotion. Spurred by this success, Dr. Finlay considered researching other possible inventions, such as devising a skate or ski for the front paws of flowerbed diggers, a muffler for habitual barking dogs and putting automatic brakes on car-chasing canines.

Cow Lawn Mowers

Elizabeth "Bessie" Pettinger recalled in *In Their Own Words* that at one time in Oswego "everybody had a cow; most everybody had a horse. They ran at large—every cow and every horse was a lawn mower!" The landscape maintenance function provided by livestock was a boon, but these animals faced many hazards.

Fencing around Sucker Lake (Oswego Lake) was to keep out cattle. *Photograph courtesy of Lake Oswego Public Library.*

Wandering cows were mired in the lake or they fell into the smoldering underground fire of the "charcoal dump." The dump was located on the terrace behind the first iron furnace where ore and charcoal had been stored in sheds. When the sheds caught fire, the charcoal dump continued to burn underground for years. Bessie's daughter Sallie Pettinger recollected that "the charcoal hill near the old furnace, sometimes set on fire by camping hobos so that it smoldered for days, became a hazard for cows, which in those days were permitted to graze wherever they wished, on hillsides or among the sweetbriar that cluttered the grassy streets."

Nellie Nelson Kyle recalled:

The cows ran at large until about 1919. They kept the streets grazed well. But a few people objected to the bells. Everyone knew their own cow's bells. Practically everyone owned their own cows and had their own source of milk and butter. And until about 1919 or thereabouts, everyone had a pasture outside. The city put into effect that cows had to be restricted.

GLORIFIED DOGS AND PLAIN OLD MUTTS

Posters touted, "Something new in Lake Grove…A modern new 4-lane highway [in other words, the newly widened Boones Ferry Road]." An all-day event on September 28, 1968, celebrated the occasion. Since the road was named after a descendant of Daniel Boone, Dallas McKennon, who played Cincinnatus on the *Daniel Boone* television series, was the guest of honor. Four skydivers jumped from an aircraft 7,500 feet above the venue. During their 2,200-foot free fall, they formed a star shape as red smoke trailed from their boots. They opened their parachutes and floated to the Lake Grove school playground with scissors for the ribbon cutting to officially open the road.

The celebration included carnival booths, prancing horses, unicyclists, square dancing, historical floats, bands and celebrities. Souvenir wooden nickels were sold for five cents. Eighty dogs were entered in the "Mutt Show," and prizes were awarded for the longest tail, the longest nose and the biggest feet. The Lake Grove Lions sold buffalo burgers and "Boone dogs" (as opposed to boondoggles), described as "glorified hot dogs." The Lake Grove Albertson's grocery store held a buffalo meat sale in honor of the event. Evidently expecting a stampede, the advertisement noted, "This buffalo will be sold on a first come first serve basis. Come early and don't be disappointed!"

Pig Penmanship

Seven Oswego women penned a letter to the city councilors on June 15, 1910. The letter read as follows: "Notice is hereby given that as the pig pen belonging to Mrs. J.J. Johnson of Oswego City has become a public nuisance on account of its vile odor and unsanitary condition, we do hereby petition our honorable body to remove said nuisance." Enforcement of this request most likely would have fallen to Oswego's first marshal, Charles N. "Windy" Haines.

MAN ABOUT TOWN

Men of Oswego

D<small>ID YOU KNOW</small>?

- In 1947, national news media reported that Gibson Kingsbury of Oswego had invented a men's suit fabric that changed colors with the tug of a drawstring. The miracle fabric, invented over cocktails, was named "Weavetrix." The emphasis should have been on the "trix."
- In the early 1920s, the pay for a city of Oswego marshal was $15.00 a month, plus $1.50 for each arrest and $0.50 a night for janitorial duties.
- Rollie Wells once closed the Oswego Public School by stuffing the old-style radiators with Limburger cheese.

K<small>RUSIN</small>' F<small>OR A</small> B<small>RUISIN</small>'

A medical condition commonly known as cauliflower ear is prevalent among wrestlers, but broccoli was the vegetable most often associated with Bob Kruse.

In his long wrestling career, Kruse was best known as "Broccoli Bob," but he was also called the "Cabbage King" and the "Oswego Farmer." The "Broccoli Bob" moniker was earned the year he grew twenty acres of broccoli on his Oswego farm. At one time, Kruse was the United States amateur heavyweight wrestling champion. His career spanned two decades, from the 1920s until the late 1940s.

A 1925 photograph of Bob Kruse, also known as "Broccoli Bob," the famed Oswego wrestler. *Photograph courtesy of Lake Oswego Public Library.*

Some of Kruse's colorfully named opponents were "Handsome Ira," "Seattle Swede," "Wild Bill Donovan" and the "Serbian Firebrand." In 1927, the *Oregonian* covered a match between the Oswego farm boy and "Kilonis the Greek," who was billed as "the roughest bone crusher that ever hit Portland." Reportedly, several times during the match "Kilonis attempted to ruffle Kruse's feelings by hitting, biting, and gouging him but the stolid farmer lad kept as cool as one of the well-known cucumbers that he cultivates on his Oswego farm."

HUCK FINN HEAVEN

The Twinings created one of the most remarkable family military traditions in American history dating back over ten generations. About 1910, Clarence Twining, recently remarried after being widowed, moved his bride and his eight children from the "Swiss cheese capital of the U.S."—Monroe, Wisconsin—to Glenmorrie. The boys in particular found the undeveloped countryside around Oswego a "Huck Finn heaven."

For the dust jacket of Mary Goodall's book, *Oregon's Iron Dream*, Nathan Twining contributed the following:

> *My years in Glenmorrie stand out as the happiest ones of my youth. I can still vividly see the unspoiled country filled with every imaginable type of game, the Oswego Lake where we swam and went boating and the picturesque Willamette River close to the house where we had wonderful fishing experiences—these are my most treasured boyhood memories.*

Three Twining sons—Robert, Nathan and Merrill—had distinguished military careers. Robert served as a captain in the United States Navy, Nathan became chairman of the Joint Chiefs of Staff under President Eisenhower and Merrill was a Marine Corps lieutenant general. Merrill was promoted to a four-star general upon his retirement.

The Twining boys' uncle, Harry L. Twining, invented an "ornithopter" in the early 1900s. It was a bird-winged contraption that never flew. Perhaps a more apt name would have been "dodothoper" after the flightless dodo bird.

A Fine Ladd

William Sargent Ladd was just a lad of limited means when he disembarked at the Portland docks in 1851 with a wine and liquor consignment financed by his friend Charles E. Tilton. Ladd soon sold the goods, rented a store and sent for more liquor. At that time, Portland, with a population of 821, was the largest settlement in the Pacific Northwest and supported about half a dozen saloons and liquor stores. Ladd was so successful that at the age of twenty-seven he became Portland's mayor, a position he would hold twice.

Ladd was paralyzed from the waist down in his early fifties, but his ability to make money remained unimpaired. He played a pivotal role in the economic development of the Portland area. In addition to the Oregon Iron Company in Oswego, he was involved in founding many enterprises, ranging from Portland's first bank, the Ladd and Tilton Bank, to River View Cemetery. Ladd also platted the Ladd's Addition neighborhood of Portland.

Ladd was a civic leader and philanthropist who reportedly donated one-tenth of his income to charity. Later in life, he opposed the selling of liquor, although ironically that is what launched his career in Portland.

Ladd was by far the wealthiest man in the Northwest when he died in 1893, with an estate valued at $10 million, which is roughly $246 million in

2012 dollars. One of his sons, William Mead Ladd, carried on his father's work. Although William S. Ladd died the same year as the Economic Panic of 1893, the two events appear to have been unrelated.

Celebrity Chef

Long before Bruce Carey and Chris Israel put Portland's restaurant scene on the national map in the 1990s, Henry Thiele was attracting gastronomes to Portland. Thiele, born in Hanover, Germany, was trained as a wine maker and confectioner. He immigrated to New York in 1893 and began working at the Waldorf Astoria Hotel. After stints in San Francisco, Nome and Seattle, he accepted the position of chief steward at Portland's Benson Hotel in 1914. In 1921, Thiele opened the Columbia Gorge Hotel with Simon Benson's financial backing. Later, the entrepreneurial Thiele was involved in many enterprises, including his landmark restaurant at Twenty-third and Burnside that opened in 1932. About 1936, Thiele chose the architectural firm Barrett & Logan to design and build his magnificent five-thousand-square-foot home on the shore of Lakewood Bay. The flagship restaurant and the home have been demolished. Thiele had a son who was also named Henry and was a restaurateur who operated two restaurants on the Oregon coast and one in Salem.

Who's Buried in Linus Pauling's Grave?

The 1954 Nobel Prize in chemistry and the 1962 Nobel Peace Prize were awarded to a person with strong ties to Oswego: Linus Carl Pauling. Other than Marie Curie, he was the only person to win two Nobel prizes in different fields. He was also the only person to win two unshared Nobel prizes. Pauling's grandfather came to Oswego to work at the second iron furnace. Pauling was born in Portland, but as a baby he and his parents lived briefly on Second Street in Oswego. His grandparents, Charles H. and Adelheid, lived on Fourth Street, and the family customarily vacationed every summer with them. This house still stands in the First Addition neighborhood. Herman Pauling, Linus's father, was apprenticed to an Oswego druggist, and this became his vocation.

Linus Pauling was a brilliant scientist and a controversial individual. A complex and outspoken larger-than-life figure, Pauling earned epithets

ranging from wizard to fascist. Pauling passed away in 1994 in Big Sur, California. A cenotaph, or marker placed to honor a person buried elsewhere, was placed in the Pauling family plot in the Oswego Pioneer Cemetery by Pauling's sister, Pauline. Many people assumed that Pauling was buried there. Actually, it was not until 2005 that Pauling's ashes, along with those of his wife, were moved from Big Sur to the Oswego Pioneer Cemetery.

CALLING ALL COCKNEYS

J.R. Irving lived in the 1877 Carpenter Gothic–style farmhouse his father, Robert James Irving, built on the land where the Oswego Towne Square in Mountain Park is today. Irving Sr. made his fortune as a soap manufacturer. He was the first person in the area to own a car. It was a chauffer-driven Lozier, the most expensive car built in America at the time. In 1894, after a downturn in his fortunes, Irving sold his landholdings in the West Hills to Henry and Georgiana Pittock, and in 1914 they spent $100,000 to build a mansion on that acreage.

J.R. Irving told a Work Projects Administration interviewer in 1939:

> *Yes, we got a telephone 'ere. I bet it's the honly one of its kind in the world. Habout thirty years ago twelve of us 'ere in this community got together an' built us a telephone line. We got the poles an 'ad the wires stretched an' then we got connection with Portland an' now* [expletive deleted] *they can't get rid o' us.*

The interviewer added the following note: "While Mr. Irving received what education he has in this country, strangely enough, he is strongly addicted to cockney English, which the interviewer has tried to reproduce, together with his healthy profanity."

A NEW WRINKLE

This is the remarkable story of a Chinese cobbler named Kie Lee who opened a shoe repair shop in Oswego in 1949 and operated it for twenty-one years. Kie Lee, although reared in Portland, was born in the village of Hoy Sun about two hundred miles from Hong Kong. In 1928, he visited his ancestral home, and he wed Lew May Tang in a traditional arranged marriage. Kie Lee's life then took an unexpected turn.

Immigration laws at that time prohibited Chinese from becoming American citizens, so he could only remain in China for one year if he wished to return to the United States. His bride was not allowed to accompany him. Kie Lee decided to return to his business in Oregon. In 1932, he was able to visit his wife, and they had a son named Gene. The lack of a marriage certificate, red tape, World War II and decades intervened. The Japanese occupation and the subsequent Communist takeover prevented Kie Lee from sending money or packages to his wife and son. Lee was finally able to become an American citizen in 1950, and he started what turned out to be an eight-year process of bringing Lew May Tang to Oregon. It was twenty-six years before they were happily reunited at the Portland Airport in 1958. Kie Lee described the changes time had wrought: "I lost some hair; she got a wrinkle."

WHO WAS FERDINAND HEINRICH GUSTAV HILGARD?

In 1882, financiers Henry Villard and Simeon Gannett Reed purchased the Oswego Iron Company. The company's new name, the Oregon Iron & Steel Company, reflected the change in ownership and the intent to add steel products. Villard's primary interest was in building the Northern Pacific Railroad, a transcontinental line to connect Chicago with Seattle. The iron industry could provide rails for the undertaking and could subsequently distribute iron nationwide. Villard's detractors did not like his tactic of buying the competition to create a monopoly. Villard was singularly undeterred. In 1883, Ulysses S. Grant drove the "golden spike" that completed the line. This transcontinental route eventually helped change the face of the nation, but the iron industry in Oswego was shuttered by 1894.

Villard was born in 1835 in Bavaria under the name Ferdinand Heinrich Gustav Hilgard. At the age of eighteen, without his parents' consent or knowledge, he immigrated to the United States and changed his name to "Henry Villard." In his first career as a journalist, he covered Abraham Lincoln's 1860 presidential campaign. As a war correspondent, he covered the American Civil War and the Austro-Prussian War. These firsthand battle experiences prompted Villard to become a pacifist. He married Helen Frances "Fanny" Garrison, a suffragist and a founding member of the National Association for the Advancement of Colored People (NAACP), the oldest civil rights organization in the United States. Among his other accomplishments, he owned the *New York Evening Post* and the *Nation*, and he

An Oregon Iron & Steel Company stock certificate; Henry Villard was a major investor. *Image courtesy of Lake Oswego Public Library.*

was the first major benefactor of the University of Oregon. At the end of his life, Villard wrote his memoirs with the proviso that they not be published for twenty-five years. Villard died in 1900, and his memoirs were published in 1904.

THE CAPITALIST AND THE COMMUNIST

Ironically, John Silas Reed, whom to many Americans became the symbol of the Communist revolution in Russia, was born in a Portland mansion named Cedar Hill. This estate belonged to his maternal grandfather, Henry Dodge Green, a prominent Portland capitalist. The Greens were the second-wealthiest family in Portland at the time. Henry Green, his brother John and William S. Ladd incorporated Oswego's first iron company, the Oregon Iron Company, in 1865. Hermon Camp Leonard, a fellow iron company investor, was also a partner with the Green brothers. Together they owned the Portland Gas Light Company and the Portland Water Company and were involved in several other enterprises. Green and Leonard Streets in Lake Oswego's Old Town neighborhood are named in their honor.

Another tie to Oswego is that Louise Bryant married Paul Trullinger, a descendant of John Corse Trullinger, the second owner of part of the

original Oswego town site. Trullinger and Bryant lived on a houseboat on the Willamette River. Bryant kept her maiden name and an apartment in Portland. As a leftist and a feminist, she was intrigued by Reed's writings, and they met in Portland about 1914. A few years later, Bryant left Trullinger to live with Reed, and they eventually married. Reed described her as "an artist, a joyous, rampant individualist, a poet and revolutionary." They spent the next four years together, and during this time they could be characterized as political activists, investigative journalists, revolutionaries, war correspondents, poets, Bohemians and world travelers. In 1920, Reed contracted spotted typhus, and he died in Russia with Bryant by his side. The year before his death, Reed's firsthand account of the Russian Revolution of 1917, entitled *Ten Days That Shook the World*, was published. Reed is the only American buried in the Kremlin Wall Necropolis in Moscow's Red Square.

13

A Woman's Place
Women of Oswego

Did you know?

- Lake Oswego's Mrs. Jack Hagan was chosen as Mrs. Oregon in 1964. A photograph taken during the pageant shows Evelyn Kay flipping a pancake with a frying pan in hand while her husband holds out his plate. This wouldn't have been unusual, except that this "cooking" demonstration took place completely under water at Weeki Wachee Springs, Florida.
- In 1912, women won the right to vote in Oregon, and eighty-five-year-old Mrs. Baker was the first woman to vote in an Oswego election. Three years later, in 1915, Mary C. Smith ran unsuccessfully for city council. A woman did not serve on council until Ellen R. Bergis was elected in 1954.
- Peg Bracken, author of the bestselling and entertaining 1960 *I Hate to Cook Book*, reportedly lived briefly in Lake Oswego. Bracken explained, "This book is for those of us who want to fold our big dish-water hands around a dry Martini instead of a wet flounder." She also viewed leftovers as the reason every family should have a dog.

Stray Dogs and Straying Daughters

The first municipal policewoman in the nation, Lola Greene Baldwin, retired to Lake Grove in 1922 at the end of a remarkable Portland-based

career. During and after the 1905 Lewis and Clark Exposition, young women without chaperones flocked to Portland to live and work. Baldwin's concern was that they would be prey, as women in other cities that hosted exhibitions had been, to white slavery, saloons, brothels, amusement parks and ragtime dance halls. Diminutive in stature, but with a commanding presence, Baldwin appealed to the Portland City Council. She pointed out that $6,000 had been allocated for a dog pound and promised that with half that amount she could help at-risk women. Spending more on stray dogs than on straying daughters embarrassed councilors into appropriating the $3,000.

To receive the funding, Baldwin was required to pass a civil service test. High marks earned her the supervisor's position of what became a new special department, the Women's Protective Division, within the Portland Police Department. With this appointment, in 1908 Baldwin became the first female municipal police officer in the United States. Baldwin chose to

Lola Baldwin forged a career path for policewomen such as Lake Oswego's Doris Volm (left) and Clarice Maxwell, on the job in 1964. *Photograph courtesy of Lake Oswego Public Library.*

keep her badge in her purse, not to carry a gun and to wear dark clothing so that she would be more approachable to those she was intent on helping. Baldwin was instrumental in getting a dance hall ordinance passed that temporarily banned dancing on Sundays and hugging at public dances in Portland. Some dancing venues shifted to riverboats outside the city's jurisdiction. One oft-repeated anecdote is illustrative of Baldwin's resolve. A disgruntled man pulled a revolver on her, and she calmly told him to go ahead and shoot since her work would be carried on after she was gone. The assailant left Baldwin's office without incident and was later convicted and imprisoned.

THE WIG OF THE BIGWIG'S WIFE

Local legend has it that there is a direct connection between the construction of the Elk Rock Tunnel and an Oswego resident. At the time the tunnel was built in 1921, Mrs. Lawrence Newlands, whose full name was "Winewood Machar Fraser Newlands," was the wife of the vice-president and manager of the Oregon Portland Cement Company at Oswego. The Newlands lived on Furnace Street in the Old Town neighborhood. Sallie Pettinger, a friend and neighbor of Mrs. Newlands, recalled that in 1919, "I happened to be riding to Portland with Mrs. Ella [sic] C. Newlands, wife of the president [sic] of Oswego Cement Company [sic]. A rock of considerable size [actually a five-hundred-pound boulder] from the Elk Rock bluff crashed through the top of the coach, inflicting a cut on Mrs. Newland's forehead, a cut requiring several stitches." Mrs. Newlands's hair was shaved, so until it grew back, she wore what she called a "transformation" and what others would call a "wig."

Falling rocks on this section of the trestle were a chronic problem from the time the line opened in 1887, but it is doubtful Mrs. Newlands's mishap was directly responsible for the construction of the Elk Rock Tunnel. An account in a 1921 issue of the *Southern Pacific Bulletin* states, "After an exhaustive study of some eight different plans for the betterment of the service and protection of traffic over the trestle, authority was given for the construction of a tunnel and the removal of the trestle."

The *Southern Pacific Bulletin* also relates that the 1,395-foot tunnel was built from both ends and met at the center with an eighth-inch tolerance. Some of the excavated basalt was dumped into the Willamette River, and the tunnel's interior was lined with fragrant Port Orford cedar (the wood was destroyed by a fire in 1967). Work forces of 80 to 175 men were employed for six

A train as it passes through the north end of the newly constructed Elk Rock Tunnel in 1921. The soon-to-be-dismantled trestle can be seen on the left. *Photograph courtesy of Lake Oswego Public Library.*

months, from June 1 until the tunnel's completion on December 5, 1921. It was noted:

> *The tunnel being situated in a fine suburban residence section* [Dunthorpe] *no suitable camp site could be found. The Hauser Construction Company then secured the one-time palatial river steamer* T.J. Potter *and the vessel was moored at the southerly end of the trestle and used for quarters for the men. It is doubtful if a tunnel gang ever had such quarters before.*

FOOD FIGHT

Sarah Ann Shannon Evans fought and won many battles in her lifetime, including a 1905 "food fight." Evans, appalled by the deplorably unsanitary conditions of Portland markets, crusaded for better conditions. Evans's activism led Portland's mayor to appoint her the first female food inspector, and she held this job for thirty years, until her retirement. According to an

essay in the book *With Her Own Wings*, Evans was known for her preparation of eggplant. In the early 1900s, eggplant was difficult to find except at Italian markets, and Evans introduced many dinner guests to this unusual vegetable.

Sarah Evans, born in Pennsylvania, was a prominent attorney's daughter. She was college educated in an era when many women didn't have that opportunity. In 1892, Evans moved to Furnace Street in Oswego because her husband, William, was hired by the Oregon Iron & Steel Company to oversee iron production at the second furnace. Evans later moved from Oswego to Portland.

Sarah Evans was a dynamo who remedied many social ills and inequities in her lifetime. She tackled humane treatment of the insane, child labor laws and clean milk inspections. Evans founded the Oswego Reading Room Club and the Portland Women's Club. She lobbied for legislation that enabled the foundation of Oregon public libraries, and she was a key player in Oregon's victory for women's suffrage in 1912. She is also remembered for her role in erecting a statue of Sacajawea, a symbol for the suffragettes, in Portland's Washington Park. Sarah died in 1940, reportedly from the complications of an automobile accident.

Elizabeth "Bessie" Evans Pettinger was the only one of Sarah's three daughters to survive her mother. Bessie lived on Furnace Street, and she followed, albeit quietly, in her mother's footsteps. Bessie help found the library in Oswego, led reading groups, wrote book reviews and organized the Oswego Women's Club in 1906.

SIGNED WITH AN "X"

Mary Heacock Prosser was a successful, yet illiterate, pioneer woman. The Prosser family arrived by way of the Oregon Trail in 1853 and soon settled in the Oswego area. Henry and Mary Prosser filed for 640 acres of free land under the Donation Land Claim Act. This land included what is now called Iron Mountain.

Henry, it turns out, was a cad who soon deserted his wife and family and never returned to Oregon. Mary filed for a divorce, but with Henry *in absentia*, court transcripts indicate that Mary was blamed for being deserted. Eventually, the divorce was granted after Frances Safely Tryon and others testified on Mary's behalf. Frances was the widow of Dr. Socrates Tryon, after whom Tryon Creek and the state park are named. Frances remarried, and her second husband, Moses Young, absconded

Mary Prosser signed this receipt with an "X." It's dated October 12, 1867, and next to the "X" are the words "her mark." *Image courtesy of the Lake Oswego Preservation Society.*

with all of the money set aside for the children's educations, so Frances was a sympathetic witness.

Mary was unable to read and write, so her son George, having some education, handled the business transactions. With the discovery of iron on her land and the rise of Oswego's iron industry, Mary, as luck would have it, was sitting on a gold mine of iron. George handled leasing, and eventually selling, the mine to the iron company.

HOMEMAKERS

In 1923, Mary Margaret Goodin Fritsch was the first woman to graduate from the University of Oregon School of Architecture. Three years later, she became the first woman to be licensed as an architect in the state of Oregon. She remained the sole female architect in Oregon until 1942. For a time, she lived on Eighth Street in Oswego. According to a 1949 article in the *Oregonian*, Fritsch's main focus was on domestic architecture, and she didn't create designs using any single particular style. Fritsch was quoted as saying, "I am not interested in erecting a monument to myself but a place to live for my client."

Marjorie McLean Wintermute, another pioneering female architect, lived the last ten years of her life in Lake Oswego. A 1992 American Institute of Architects MatriArchs exhibit quoted Wintermute as saying:

> *Then I did a thing which I would never have done today. I got married in 1947 and quit working for Pietro's* [Belluschi's] *office because that was*

what was expected in my time. I continued working out of my home—mostly residential work…When I think of it now…I was working for Pietro and I quit! Can you imagine! Stupidest thing I ever did.

Wintermute received many awards in her career and was one of the first women in America to be elevated to fellowship in the American Institute of Architects. This is a distinction that recognizes architects who have made a significant contribution to architecture and society and who have achieved a standard of excellence in the profession.

THE BOOK THAT BUILT THE LIBRARY

Usually libraries are built for books. In the case of Oswego, it was a book that helped build the library. Civic leader Mary Goodall donated proceeds from her 1958 history of Oswego entitled *Oregon's Iron Dream* to the Friends of the Library for construction of the Lake Oswego Public Library on Fourth Street that preceded the current structure.

In addition to her efforts on behalf of the library, Mary Goodall worked tirelessly to save the town's historic structures and trees. Her accomplishments included preserving the iron furnace, the historic Peg Tree and the giant sequoia at Fifth Street and A Avenue that now serves as the city's holiday tree. One major setback was losing the historic J.R. Irving House in

Mary Goodall (right) presenting a check for $2,800 to Bea Silvander and Isabel Stidd. Proceeds from the sale of *Oregon's Iron Dream* were donated to the library-building fund. *Photograph courtesy of Lake Oswego Public Library.*

Mountain Park to a shopping center, but because of this effort, she founded the Oswego Heritage Council in 1970. Goodall also served on the Lake Oswego City Council for eight years and sponsored the first ordinance to protect our urban forest.

On May 6, 1989, two months before her death, a stroke had made it difficult for her to write, but she scrawled a note to the Lake Oswego Development Review Commission regarding an upcoming hearing on the Pfeifer Pony Farm in the Holly Orchard neighborhood. The note reads, "I am writing to ask you to deny action on the Pfeifer Pony Farm property for historic reasons. Wish I could list them but it's a terrible effort to write since my stroke. I now live in a foster home/small rest home. Please don't let our history slip away." It is signed Mary Goodall Ramsey, former resident and member of city council. At the bottom of the note, she scrawled: "I love L.O." Unfortunately, the Pfeifer Pony Farm land and the magnificent clear fir barn on the historic John William and Metta Frances (Kruse) Stone property were lost to a housing development. Mary Goodall, until the very end of her life, fought to preserve the history of the city she so dearly loved.

Speaking of History

In 1972, Theresa Truchot, at the age of eighty-one and weighing eighty-one pounds, was the powerhouse who started interviewing Lake Oswego residents about life in the old days. Truchot considered herself a "newcomer" since she had only moved to Oswego in 1922. Armed with the encouragement and the personal tape recorder of Lake Oswego Public Library reference librarian Steve Turner, Truchot forged ahead without a budget. She compiled a list of old-timers and started with the oldest and the ill. As word about the project spread, Edwin T. Cornelius donated tape recording technical assistance. The *Lady's Circle* magazine published an article on the oral histories in the June 1974 issue. Volunteers joined Truchot's efforts, and these interviews were eventually published in 1976 to coincide with the country's bicentennial. The publication is titled *In Their Own Words*. It was the first collection of interviews with residents since a Works Progress Administration project done in the 1930s.

One interviewee, Arsenius F. DeBauw, said he witnessed the fall of the Willamette meteorite. This was quite a feat for a meteor that fell some fifteen to thirteen thousand years ago and was carried here from Montana by the Missoula Floods! In the 1940s, long before *In Their Own Words*, Truchot

interviewed Charles Towt Dickinson, who was ninety-four years old at the time. She was so fascinated with his account of working in the iron industry as a child that she wrote the book *Charcoal Wagon Boy*, and it was published in 1952. Although she raced to complete it, Mr. Dickinson didn't live to read her account. Truchot wrote a sequel, *Iron Works Boy*, which she donated to the Lake Oswego Public Library, but it has not been published.

In honor of the city's centennial of incorporation in 2010, the Lake Oswego Public Library staff members and volunteers produced an updated and illustrated edition of *In Their Own Words*, and they have undertaken a project to once again record what time and current residents will tell.

POOR LITTLE RICH GIRL

Mary Hoadly Scarborough Young, who once owned the Twin Points estate on Oswego Lake, came from a wealthy and well-connected family. Her maternal grandfather, George Hoadly, was governor of Ohio. After relocating to New York City, one of the Hoadlys' neighbors was Henry Villard, who would, coincidently, play a part in Oswego's iron industry. Other relatives had served as university presidents of Yale and Princeton.

Personal wealth and connections provided no protection from tragedy. Mary's father, Theodore Woolsey Scarborough, died at age thirty-three from typhoid fever; Mary was five years old. Mary's mother remarried, and the newlyweds relocated to Portland, Oregon. Three months after the wedding, thugs robbed and murdered Mary's stepfather, Dr. Philip Edwards Johnson, and threw his body off the Ford Street Bridge (now the Vista Avenue Bridge).

Mary, married to Thomas Earl Young, was the first to purchase a home site when the Ladd Estate Company opened up a new tract on Oswego Lake in 1931. The eight-acre parcel, and hence her estate, was named Twin Points. Noted architect Van Evera Bailey designed the house that was demolished in the early 1970s. Young was an active Oswego Garden Club member, and the gardens of her estate, designed by the firm of Lord & Schryver, along with Otto E. Holmdahl, were a showpiece.

Young funded landscape improvements in George Rogers Park, as well as working hands-on on the project. She, it is said, purchased acreage on the Willamette River south of Lake Oswego as a surprise gift for her husband after he expressed an interest in raising cattle. The story continues that Thomas objected to the money spent on the parcel and refused the gift. Young made alternate plans to build a river-view estate with tennis courts,

a shooting range and equestrian trails, but this was never realized. Young was probably driving her red Thunderbird when a Lake Oswego policeman gave her a speeding ticket. This incident may have ultimately determined the parcel's future. Angered by the ticket, Young decided to deed the nearly 132 acres to the State of Oregon instead of Lake Oswego. When the park on Highway 43 officially opened in 1973, it became the second state park in Clackamas County. Restrictions stipulated that the property be kept as nearly as possible in its natural state. The Mary S. Young Park is currently operated by the City of West Linn.

West Side Story

Anne Shannon Monroe, a prolific inspirational author, once lived on the west side of town. Her house still stands on the southeast corner of Upper Drive and Bryant Road in Lake Grove. Monroe wrote her first manuscript in

The dust jacket of the first edition of *Singing in the Rain*, published in 1926. *Image courtesy of the Lake Oswego Preservation Society.*

longhand, tucked the finished pages under her arm and headed to Chicago. She took a taxi to Rand McNally and Company and asked to speak to Mr. Rand. Astonishingly, Mr. Rand ended up publishing the book, and this was the start of her career as a writer. She wrote for *Saturday Evening Post*, *Ladies Home Journal* and *Good Housekeeping*, as well as publishing over a dozen books. One of her most notable titles, a book of essays entitled *Singing in the Rain*, was published in 1926, and within five years, over 100,000 copies had been sold. Some of Monroe's titles, such as *Making a Business Woman*, first published in 1912, are still in print.

Monroe was the great-granddaughter of George Shannon, the youngest member of the Lewis and Clark Expedition, and she was a lifelong Mazamas member. The Mazamas, founded in 1894 on Mount Hood's summit, still fulfills its mission as a mountaineering education organization.

Women Who Made Histories

Oswego was already ninety-four years old when Lucia Bliss wrote the city's first history, entitled *The Foundation: Early History of Oswego, Oregon*, in 1944. Bliss was also the city's first salaried librarian, and her chronicle forged a path for others. Theresa Truchot modeled her fictionalized *Charcoal Wagon Boy*, published in 1952, after stories told by Mr. Charles Towt Dickinson, who had worked at the first iron furnace when he was a boy. Civic leader Mary Goodall donated the profits of her 1958 book, *Oregon's Iron Dream*, toward the building of a new library. It opened in 1962 on the corner of Fourth Street and D Avenue. This building was replaced in 1983. Elizabeth Ryan didn't publish a book, but she sparked interest in local history by writing articles for the *Oswego Review* in the 1960s. Ryan's newspaper photos are now part of the library's historic photograph database. There was a publishing gap of forty-three years until Ann Fulton's 2002 book, *Iron, Wood & Water*, brought the town's history up to the 1960 annexation of part of Lake Grove and the attendant name change from "Oswego" to "Lake Oswego." A volume entitled *Images of America: Lake Oswego*, by Laura Foster, was published in 2009. *Lake Oswego Vignettes: Illiterate Cows to College-Educated Cabbage*, published in 2012, is the most recent addition to this list. If indeed, as Shakespeare said, "what's past is prologue," a woman will pen the next history of the city.

SELECTED BIBLIOGRAPHY

Foster, Laura O. *Images of America: Lake Oswego*. Charleston, SC: Arcadia Publishing, 2009.

Fulton, Ann. *Iron, Wood & Water: An Illustrated History of Lake Oswego*. San Antonio, TX: Historical Publishing Network, 2002.

Goodall, Mary. *Oregon's Iron Dream: A Story of Old Oswego and the Proposed Iron Empire of the West*. Portland, OR: Binfords & Mort, Publishers, 1958.

Hurd, Kathryn. *Briarwood Remembered*. Lake Oswego, OR: K. Hurd, 1998.

Kellogg, Claire, and Susanna Campbell Kuo, eds. *The Diary of Will Pomeroy: A Boy's Life in 1883 Oswego, Oregon*. Lake Oswego, OR: Lake Oswego Public Library, 2009.

Lake Oswego Public Library. *In Their Own Words: A Collection of Reminiscences of Early Oswego, Oregon*. Rev. ed. Lake Oswego, OR: Lake Oswego Public Library, 2010.

Truchot, Theresa. *Charcoal Wagon Boy*. Portland, OR: Binfords & Mort, Publishers, 1952.

Index

ABOUT THE AUTHOR

Marylou Colver is the founder and president of the Lake Oswego Preservation Society, a nonprofit organization (www.lakeoswegopreservationsociety.org). In addition to writing the vignettes, a number of which were originally published in the City of Lake Oswego newsletter *Hello LO*, she has contributed articles on Lake Oswego's history to the online *Oregon Encyclopedia* and the *Lake Oswego Review*. Colver also conceived and authored two major exhibits: *Lost Landmarks: The Fate of Historic Homes in Lake Oswego* and *Building Blocks: A Pictorial History of Lake Oswego Neighborhoods*.

Photograph courtesy of Corinna Campbell-Sack.

She was awarded the City of Lake Oswego Historic Preservation Merit Award and the city's Unsung Hero Award for her preservation and local history efforts, including founding the Lake Oswego Historic Home Tour. Colver is a Phi Beta Kappa graduate with a BA in English from the University of California–Riverside and a master's of library science from the University of California–Berkeley. She lives in a 1925 bungalow designated as a City of Lake Oswego Landmark.

Visit us at
www.historypress.net